IMAGES
of America

SCARBOROUGH

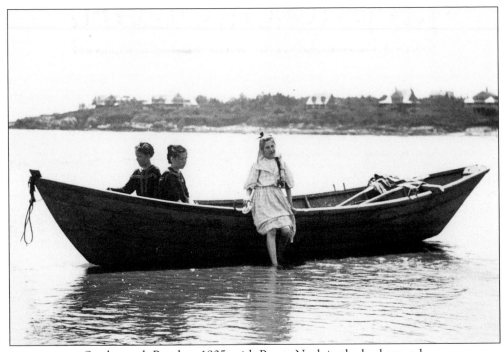

Scarborough Beach *c*. 1905, with Prouts Neck in the background.

IMAGES
of America

SCARBOROUGH

Rodney Laughton

ARCADIA

First published 1996
Reprinted 2004

Published by Arcadia Publishing,
Charleston SC, Chicago IL, Portsmouth NH, San Francisco CA

Printed in Great Britain

Library of Congress Catalog Card Number: 2004111106

For all general information, contact Arcadia Publishing:
Telephone 843-853-2070
Fax 843-853-0044
E-mail sales@arcadiapublishing.com
For customer service and orders:
Toll-free 1-888-313-2665

Visit us on the Internet at www.arcadiapublishing.com

Contents

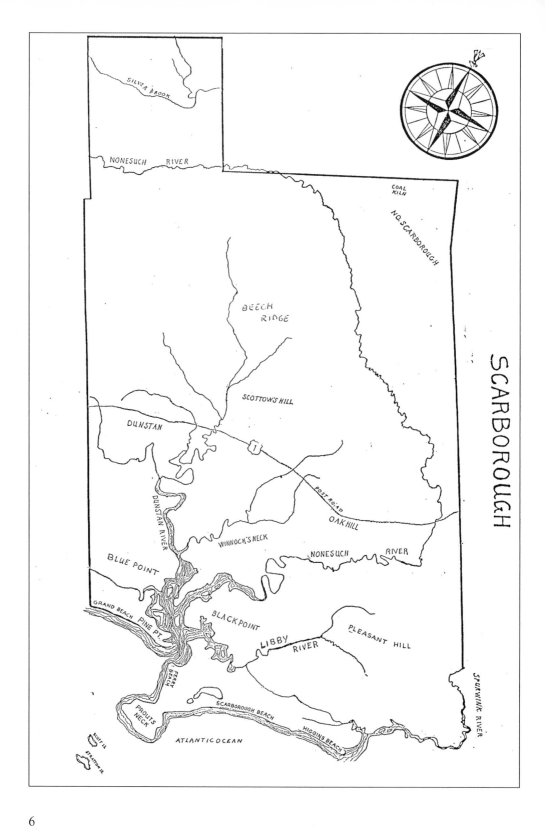

SCARBOROUGH

SILVER BROOK

NONESUCH RIVER

COAL KILN

NO. SCARBOROUGH

BEECH RIDGE

SCOTTOW'S HILL

DUNSTAN

1

POST ROAD

OAK HILL

DUNSTAN RIVER

WINNOCK'S NECK

NONESUCH RIVER

BLUE POINT

GRAND BEACH

PINE PT.

BLACK POINT

PLEASANT HILL

LIBBY RIVER

SPURWINK RIVER

FERRY BEACH

PROUTS NECK

SCARBOROUGH BEACH

HIGGINS BEACH

ATLANTIC OCEAN

BLUFF IS.

STRATTON IS.

Introduction

Scarborough, like many communities, has undergone a great deal of change in the last 125 years. In the 1870s, when the Boston & Maine Railroad established its own tracks through Scarborough, there began a chain of events that would lead the town into the twentieth century. During that decade, many area hotels were built and Scarborough established itself as a summer resort. The influx of tourists, or "rusticators," as they were called in the early years, not only provided income for the innkeepers, but also created an impact upon the entire town. Anyone who could supply a product or service benefited from the increase in the summer population.

The next major event that triggered change was the extension of the inter-urban trolley line through Scarborough just after the turn of the century. Enterprising businessmen established shore dinner houses, taking advantage of Scarborough's greatest natural resources—its lobsters and clams. Along with the introduction of residential telephone use and electric service, these developments impacted everyday life in Scarborough more than anything that had ever come before.

This collection of photographs is by no means a complete photographic history. There were places and events for which I could not find photographs. Others had to be omitted simply because there was not enough space to put them in. It would take a large volume of text to document the important events and people who shaped the town's history. I have tried to bring together a cross-section of photographs which represent development in all areas of the town. The earliest photograph presented is that of the *Delia Chapin* under construction at Dunstan Landing in 1847. The latest, with one exception, is of the Civil War centennial tribute in 1960. Scarborough is my hometown, and the production of this book is the culmination of the research I have conducted as a hobby over the last twenty years. I compiled these photographs and information, not to dwell on the past, but to reminisce, reflect, and learn about what has gone before in our town. I hope you enjoy the book as much as I enjoyed putting it together.

Rodney Laughton
March 1996

Acknowledgments

I would like to thank the following people for their help:

Nancy Walker Hoyt, granddaughter of Charles Walker, who brought her grandfather's glass plate negatives back to Scarborough, saying they did not belong in Pennsylvania;

Margaret Small, granddaughter of Fred Walker, for her generous contributions of research materials, photographs, and personal recollections;

The Scarborough Historical Society, Scarborough Public Library, the Maine Historical Society, Portland Public Library, and the Cumberland County Registry of Deeds;

Robert Domingue, Frank Hodgdon, Linwood Dyer, Peter Batchelder, Anna Delaware, Rebecca Delaware, William Littlejohn, Laura Sprague, William Bayley, and Harold Snow, all of whom hold an interest in Scarborough history and were there for me when I needed their help;

My wife Patricia, for her patience and editing;

Warren Gammons, of Cape Elizabeth, for his darkroom work;

My father, Kenneth Laughton, who told me stories of old Scarborough as I grew up. It created the interest that led me to study town history as an adult. He has been an invaluable source for recalling people, places, and events that he has known in eighty-plus years of living in Scarborough.

There were many others who took time to speak with me, supply me with a name, date, or other information. To them, I am also grateful.

The images in this book are from my private collection unless otherwise noted.

Many of the photographs were taken by Charles F. Walker.

One
Black Point

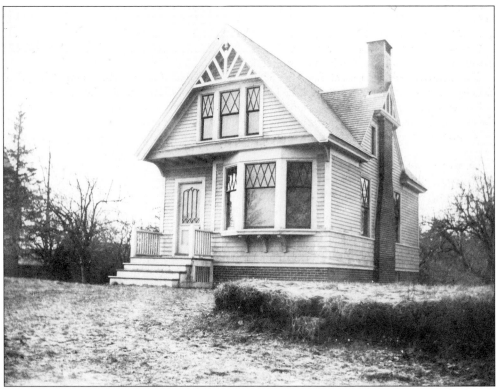

Scarborough Public Library began when a group of women from the Congregational Church collected and shared their books. The group incorporated in 1899, and a year later, the one-room library was completed next to the church. Building additions were made several times. It served the public until it was finally outgrown by the needs of the community, and a new library was built near Oak Hill. (Courtesy Robert Domingue.)

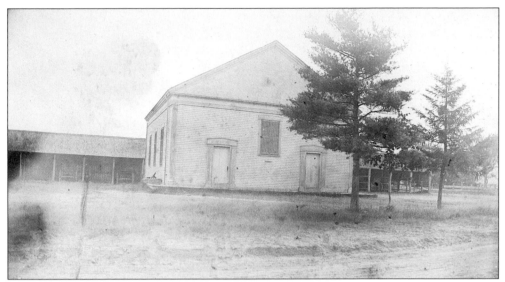

The First Congregational Church erected this building in 1844. It was the third church structure built by the congregation. Located near the railroad overpass on Black Point Road, it was known as Causeway Church. The church eventually relocated further down the road because of noise created by the railroad. Today, the building is a variety store. (Courtesy Scarborough Historical Society.)

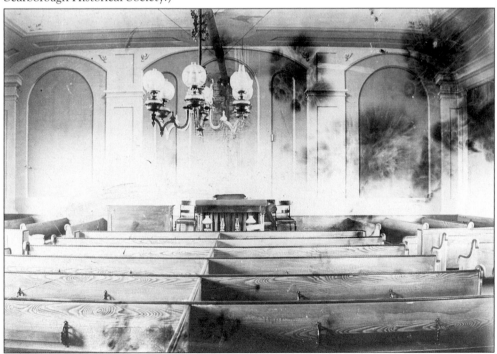

This is an interior view of Causeway Church. What appears to be a paneled interior was actually composed of painted murals. This style of work is called "trompe d'oeil," meaning "fool the eye." The murals gave the church interior a larger and more impressive look, and are considered to be among the finest examples of this style in New England. (Courtesy Scarborough Historical Society.)

The First Congregational Church was established in 1728. This meetinghouse was the fourth for the congregation, the first having been built in 1730 on the Black Point Cemetery property. This church, at 167 Black Point Road, was erected in 1893, according to plans by Portland architect Frederick Thompson. It was the first church in town to have a bell, which was donated by Colonel C.G. Thornton, of Boston. (Courtesy Margaret Small.)

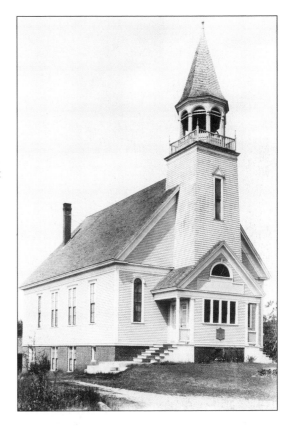

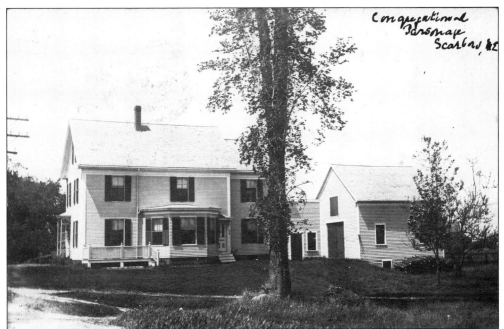

The parsonage for the First Congregational Church was built in 1881. Formerly, the parsonage was located at Oak Hill. When the church relocated to Black Point, the parsonage did as well.

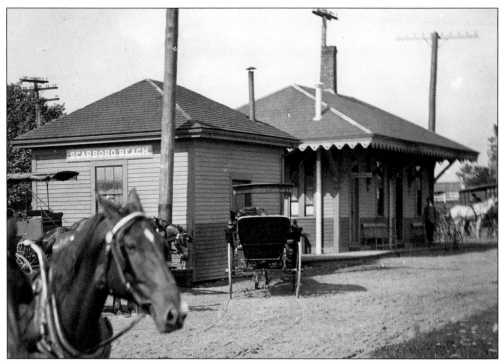

Scarboro Beach Station was built in 1873 when the Boston & Maine Railroad laid its own track through Scarborough. It was located off of Black Point Road, near the present day public works garage. Previously, the B&M had leased the tracks of the Portland, Saco, & Portsmouth Railroad, but lost its lease when that line was purchased by the Eastern Railroad.

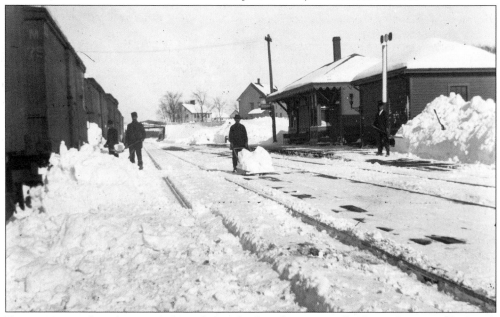

Trains were used to clear snow from the tracks, but there was still a lot to be moved by hand. The overpass of Black Point Road, the Plummer/Bowley house, and the back of the Grange Hall are in the background.

Above: This view illustrates the aftermath of the fire that burned Scarboro Beach Station to the ground on August 27, 1908.

Below, left: Elbridge Oliver (1842–1930), a public servant in Scarborough for most of his life, was station agent at the time of the fire. At other times, he served as postmaster and town clerk. He was also a selectman. (Courtesy Margaret Small.)

Below, right: An enlargement of the fire scene photograph reveals a sign advertising lots for sale at Higgins Beach.

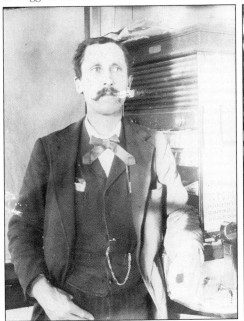 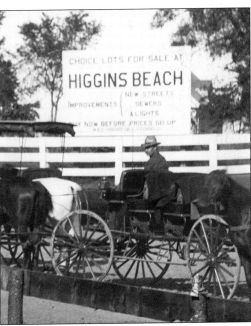

Charles F. Walker was born in Scarborough, one of four children of Daniel and Eliza Plummer Walker. For fifty-five years he was employed by the Boston & Maine Railroad, serving many of those years as station agent at Scarboro Beach Station. Mr. Walker's hobby was photography, and as the number of people visiting Scarborough in the summer months increased, he turned it into a source of income. Many of his photographs were used in hotel brochures, and he produced his own line of postcards. He became friends with the well-known artist Winslow Homer, who often used Walker's photographs for inspiration. Charles Walker died in 1939 at the age of seventy-eight. He is remembered as a kind and well-respected member of the community.

14

Lena, Henry, and Charles Walker pose for a family portrait. Charles had one son, Henry, with his first wife, Elizabeth. Tragically, Elizabeth died eight days after Henry was born. Charles married Lena Peterson of Pleasant Hill when Henry was seven. The family made their home on Black Point Road, a short walk from the train station. Lena was a seamstress, and worked out of her home for members of the community. Henry went to Harvard University, settled in Pennsylvania, and pursued a career in business.

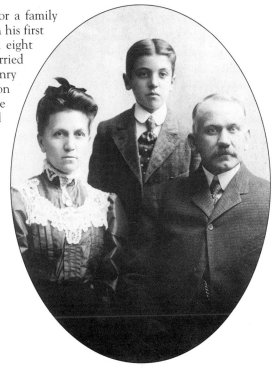

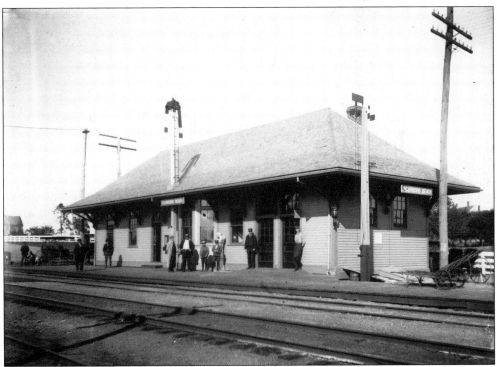

A new and larger Scarboro Beach Station, built at the same location as its predecessor, was finished in time for the busy summer season of 1909. It was at this time that Charles Walker succeeded Elbridge Oliver as station agent.

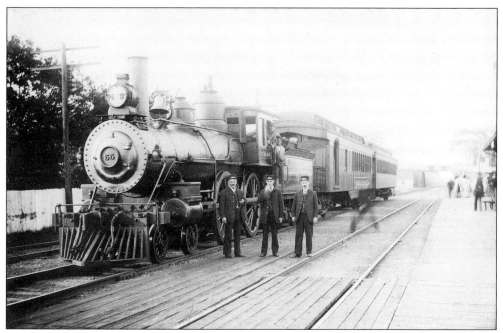

Charles Walker is on the on left, the center man is unidentified, and Fred Walker is on the right in this photograph of a locomotive and cars at the station. The overpass on Black Point Road can be seen in the distance.

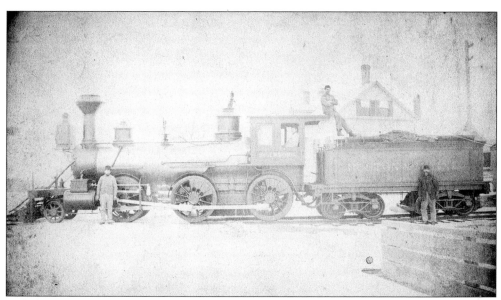

The steam locomotive Scarborough was built by the Portland Company. It was delivered to the Portland, Saco, & Portsmouth Railroad on December 26, 1871. Originally designed to burn wood for fuel, it was later converted to a coal-burning system. The locomotive eventually became the property of the Boston & Maine.

Walter Larrabee and his sister, Mary Foss, make their way to the train station. Newcomb's store is shown before its reconstruction. Charles Walker's house is on the right behind the trees.

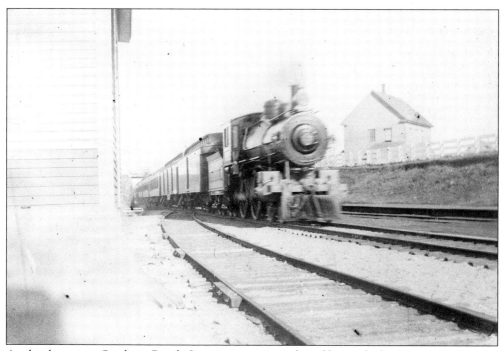

A whistle stop at Scarboro Beach Station was captured on film, with the Grange Hall in the background.

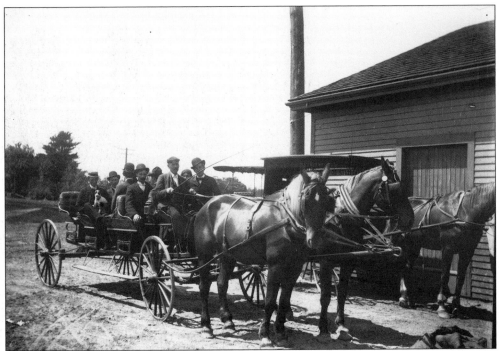

In the earliest days of transporting people to and from the train station, simple farm wagons were used. As time progressed, another style of wagon was introduced. Known as "barges," some of these vehicles were completely open and some had canvas tops. They all had several rows of seats to accommodate as many people as possible. Most of the hotels had their own, identified by the name painted on the side. In this photograph, Harris Seavey is at the reins of the Checkley barge.

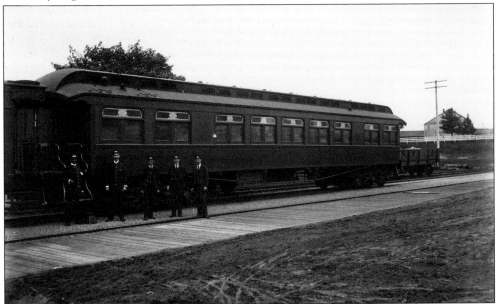

Conductors for the Boston & Maine take time to be photographed at Scarboro Beach Station. The Congregational church can be seen in the distance.

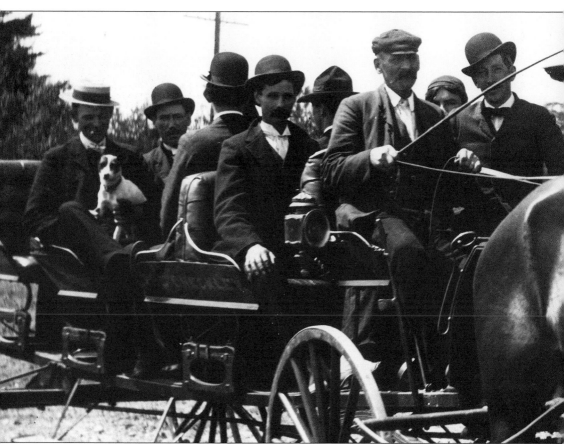

Harris Seavey was best described by Dr. James M. Farr, in an address he made to the Prouts Neck Association on August 3, 1951: "Harris Seavey was our first Prouts Neck acquaintance. He was an unforgettable character, with the bluest eyes you ever saw, with wrinkles at the corners indicative of his smiling good nature. He had a long drooping mustache, a battered old hat, and a generally unkempt appearance (he shaved on Sundays), but no one could doubt the friendliness of his nature."

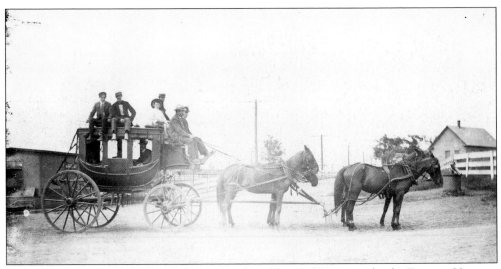

This classic Concord Coach was built in 1879 by Abbot and Downing for the Farragut House, a hotel in Rye Beach, New Hampshire. Harris Seavey bought the coach c. 1900 and had it shipped by rail to Scarborough. Named Talley-Ho, the coach was bottle-green and had yellow wheels. The body was suspended on leather straps instead of leaf springs like most carriages of the day. Harris used it as a taxi, transporting people from the station to the hotels at Prouts Neck.

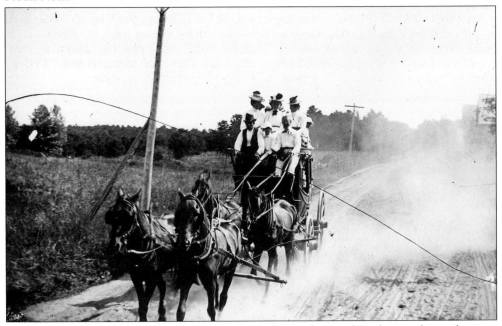

Quoting again from Dr. Farr's address: "We climbed onto the coach with something of a sense of adventure . . . The high spot of the journey, the moment of Harris' pride and joy, was when we drew near the little hill where the road branches off to Higgins Beach. There Harris gathered his reins together, cracked his whip, shouted 'gip-up thar,' pelted the leaders with pebbles from his pocket, and the four horses started off on a mad gallop until the hill top was reached, where they settled down to a jog trot again; and so a few minutes later we came to Prouts Neck, our journey's end."

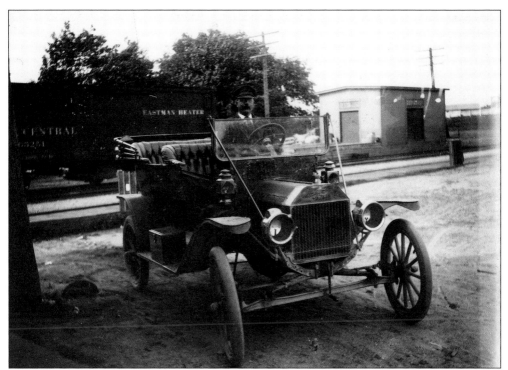

Al Skillings (1863–1918) was a clam digger by trade, but like many Scarborough residents, he found extra work during the summer months when there was an influx of tourists. He is remembered for the meticulous way he kept his horse and barge. He is seen in many photographs around Scarboro Beach Station, first with his horse and then later in this Model T Ford. He was married to Sarah Arrowsmith. They lived on Highland Avenue.

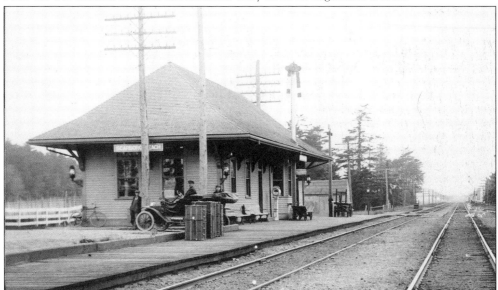

Al Skillings, in his Model T, is backed in beside the station and is waiting for a passenger. Steamer trunks are in line on the siding. The photograph was taken looking in the direction of Pine Point.

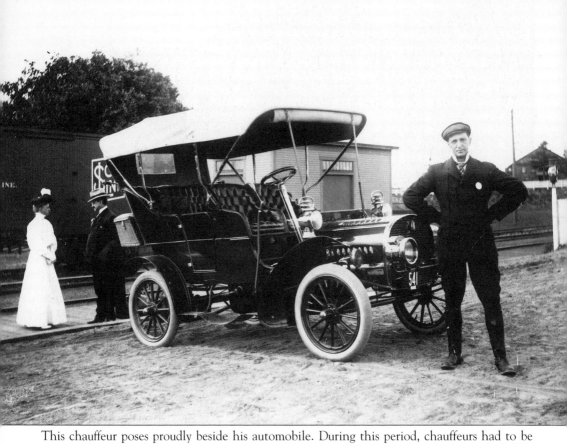

This chauffeur poses proudly beside his automobile. During this period, chauffeurs had to be registered in Massachusetts (but not in Maine). Identification was issued in the form of a badge, which this driver is wearing on the left side of his jacket.

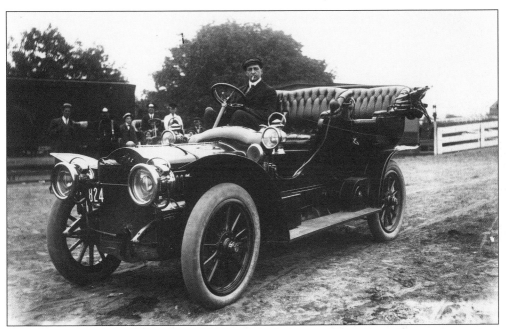

This fine automobile, believed to be chauffeur-driven, is shown stopping at the station, probably waiting for the train to arrive with the car's owner. Many of the first automobiles in town belonged to people summering at Prouts Neck. In the background, George Robinson, Al Skillings, and several locals look on.

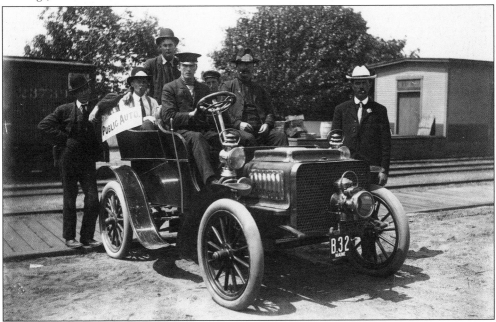

George Robinson is shown here at the wheel of his 1905 Rambler. He is credited with being the first year-round Scarborough resident to own an automobile. He is parked at the station, where he made money taking passengers to and from the hotels at Prouts Neck. The building in the background was a freight shed for the railroad and was later incorporated into the public works garage.

SOUVENIR

Black Point School

SCARBORO, MAINE.

April 6, 1903 --- June 26, 1903.

Ethelyn W. Moulton,
Teacher.

LIDA E. LIBBY. - Supt. of Schools.

Black Point School was a one-room schoolhouse located on Black Point Road near Spurwink Road. This souvenir of the 1903 spring term listed the following students: Ellen Harding, Roy Harding, Nelly Harmon, Jenny Harmon, Arlene Harmon, Carl Harmon, Leon Harmon, Elver Harmon, Marion Libby, Stella Libby, Lucien Libby, Lucy Lee, Harry Lee, Robert Lee, Bertha Newcomb, Bertha Meserve, Willie Meserve, Eddie Meserve, Ruth Milliken, Elsie Skillings, Winnie Skillings, Herbert Skillings, and Henry Walker. The school still stands, remodeled as a duplex.

These students at Black Point School in October 1941 are, from left to right: (front row) George Frederick, Sheila Swinburne, Mark Healy, Betty Hunnewell, and Stewart Harmon; (back row) Homer Meserve, Jane Libby, Donald Larrabee, Miss May (teacher), Carolyn Bryant, and Richard Hunnewell. (Courtesy Jane King.)

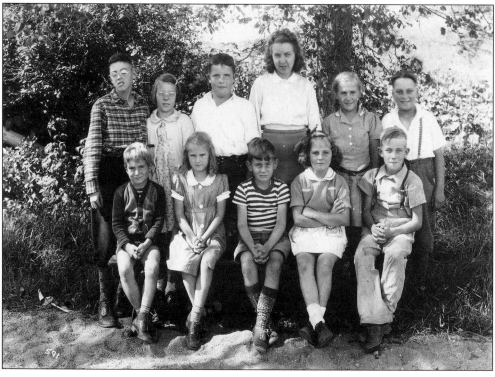

Lawrence Googins operated this blacksmith shop on Highland Avenue, not far from Scarboro Beach Station. Almost every neighborhood had one or more blacksmith shops. They faded away when the automobile replaced the horse as the primary means of transportation. (Courtesy Scarborough Historical Society.)

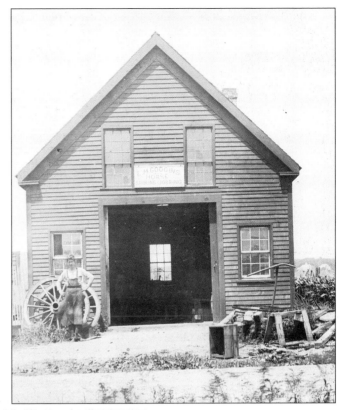

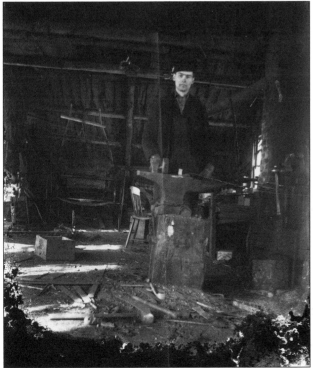

This is thought to be a photograph of Lawrence Googins. He lost his life during the Boxer Rebellion, a movement by the Chinese government to expel foreigners and foreign interests. The United States, along with five other nations, sent troops to suppress the uprising and protect their interests. Googins, aged twenty-five, was killed in the line of duty on August 5, 1899, in Tien Tsin, China. It took until the following February for his body to be returned to Scarborough. He is buried in Black Point Cemetery.

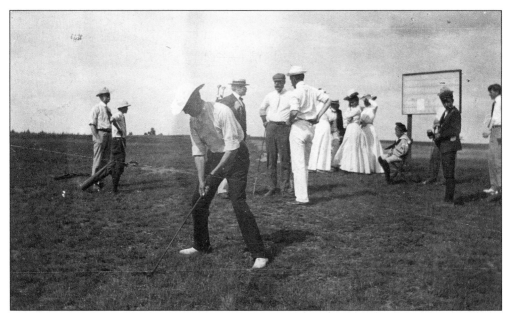

In 1900, a group from Prouts Neck rented property behind the cemetery on Black Point Road, and established the Owascoag Golf Club. A 9-hole course was laid out. It was primitive by today's standards, but has been described as picturesque. Formerly a sheep pasture, the rolling grounds were dotted with juniper and blueberry bushes. Even though it was very basic, the players found the course to be a challenge. (Courtesy Dino and Barbara Giamatti.)

The golfers rented a room in this house, which still stands today, at 222 Black Point Road. The clubs were kept here and it served as headquarters. Probably, on more than one occasion, it was used to escape a thundershower. During the days of the big hotels at Prouts Neck, the golf club flourished. With the purchase of the Wiggin Farm and other adjacent property in 1906, construction on the Prouts Neck Country Club and a 9-hole course soon began. The new site was more conveniently located, and the the Owascoag Golf Club was given up.

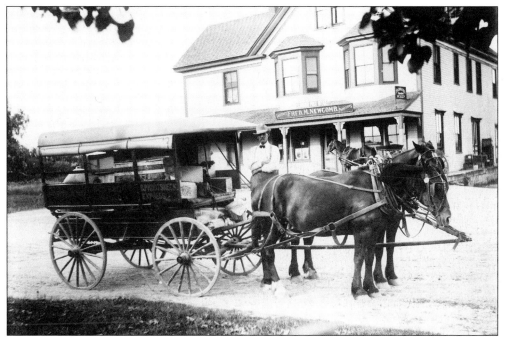

Mr. Newcomb and V.T. Shaw kept stores in the area of Black Point Road because of the proximity to the train station. The building looks the same today as it did when this photograph was taken. Along the side of the delivery wagon is printed "Portland, Prouts Neck and Scarboro Beach Express." The wagon and team were the equivalent of the private parcel delivery companies of today.

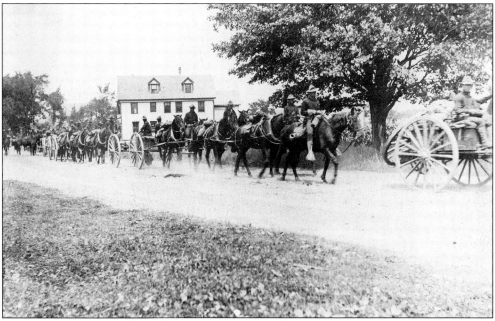

The United States Cavalry makes its way down Black Point Road in 1900. Newcomb's store can be seen in the background. The troop was en route from New Hampshire to Cape Elizabeth. (Courtesy Jane King.)

The Larrabee Farm on Black Point Road has been in that family for several generations. Around 1910, when Walter Larrabee married Daisy Butterfield, the roof was raised and a second floor built. This was a common practice among farm families at the time, and made living space for the newlyweds on one floor and Larrabee's parents on the other.

Reverend Thomas Lancaster's house, at 182 Black Point Road, was built in 1763. At the time, it was the parsonage for the First Congregational Church. The house and many of its original architectural details have been well preserved. Original hinges on a pair of cupboard doors are decorated with crowns, subtly exhibiting loyalty to England at a time when colonists were divided over the issue of American independence. Interestingly, when the house was built, it was customary to hold funerals in the parsonage. The extra width of the front door accommodated the easy passage of a casket. The house is said to have been a stop on the Underground Railroad for slaves making their way to Canada during the Civil War. (Courtesy Jane King.)

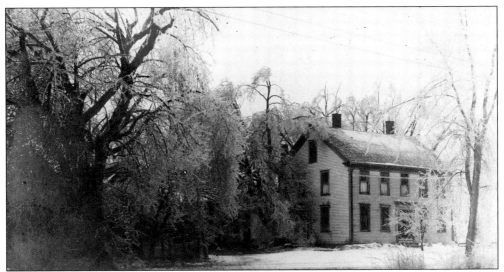

George Washington Libby built this house on Black Point Road *c.* 1850. Located next to the Grange Hall, it is often referred to as the Chet Fogg place, for a market gardener who resided here. The house is scheduled to be demolished in 1996 when the railroad bridge nearby will be relocated and rebuilt.

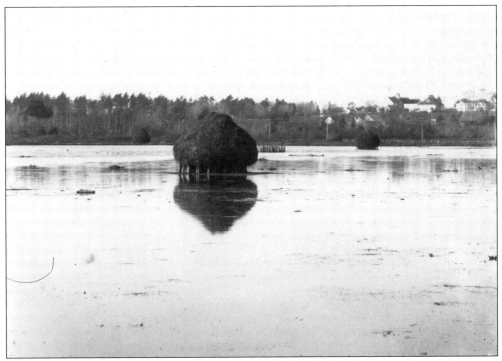

Salt hay was piled on staddles to protect it from the flood tides that cover the marsh once a month. The wooden staddles were usually made of chestnut, because it did not rot as quickly as other woods. Branches were laid down and then the hay was piled on top. Long poles were passed underneath and were used to lift the pile without dismantling it. This photograph was taken near the Winnocks Neck Road looking toward Oak Hill.

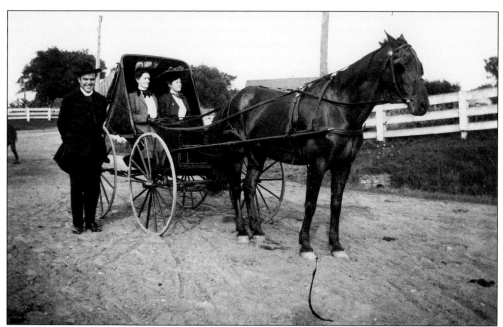

This clergyman and ladies were photographed in the vicinity of the station. Unfortunately, their identity is not known, but the photograph's subjects remain interesting: the ladies in their Sunday dress, the carriage, and the minister's smile, which is rarely seen in early photographs.

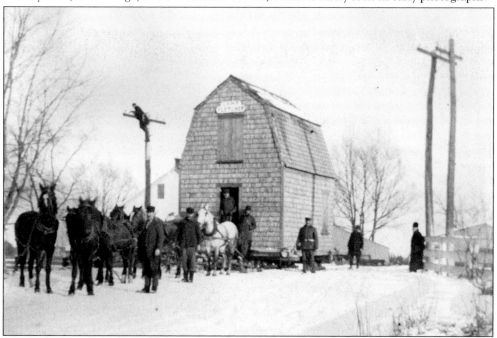

This photograph captures Camp Fletcher being moved across the railroad overpass on Black Point Road. Many buildings were built on posts and it was not uncommon for a property owner who liked his location, but not his house, to move it and build a new one. At Higgins Beach, cottages were often shuffled from lot to lot. These moves were usually made in the winter when slippery conditions could be used to the mover's advantage. (Courtesy Jane King.)

Two

The Scarborough
Beach Area

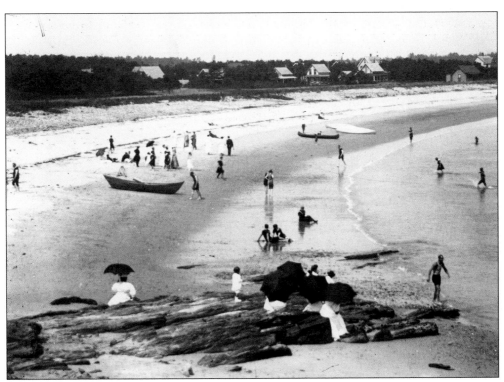

At the "bathing beach" women dressed in long gowns and men always kept a shirt on. Canoes and dories are on the beach, ready to launch for a ride offshore. With parasols in hand, the women in the foreground sought to protect their complexions from the sun. At the turn of the century, fair skin was admired, in contrast to the tanned look of today.

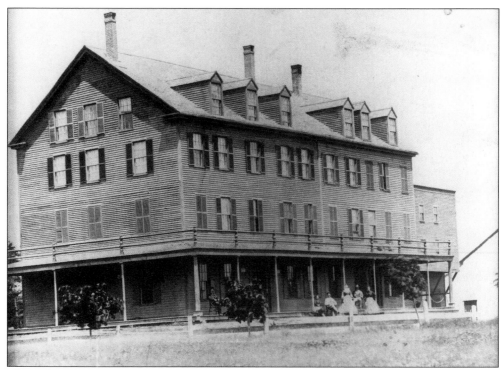

The Atlantic House was established in 1850 when Enoch Nutter started renting rooms in his farm house at Scarborough Beach. Five years later, the first addition was built due to the growing demand for more rooms. This is one of the earliest known pictures of the hotel. (Courtesy Dino and Barbara Giamatti.)

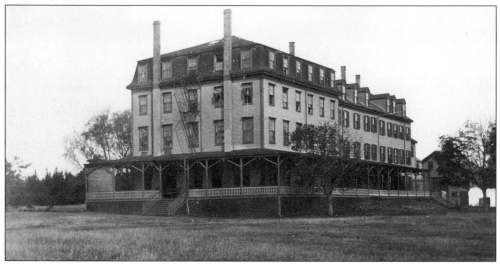

The section to the left facing the hotel was added in 1877, and by 1911 a third section had been added onto the right. Unfortunately, the oldest part of the hotel, by that time located in the center, was showing signs of age. During the off-season this old section was completely ripped out and a new center section built before the summer season of 1912. Looking at latter-day photographs, the different roof lines distinguish the sections of the building. (Courtesy Jane King.)

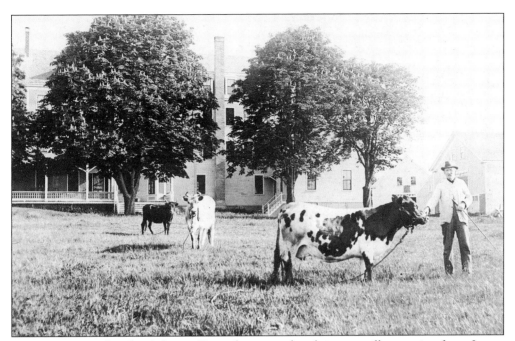

For many years after the Atlantic House became a hotel, it was still an active farm. It was common practice to stake the cows out on the front lawn to graze. (Courtesy Dino and Barbara Giamatti.)

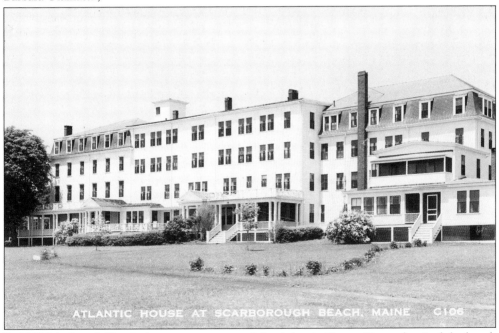

ATLANTIC HOUSE AT SCARBOROUGH BEACH, MAINE C106

In 1923 Mr. Joseph Knight became proprietor of the Atlantic House. He modernized the hotel, installed an elevator, and redecorated the lobby to include murals by local artist Roger Deering. After Mr. Knight's retirement, his son Harry ran the hotel until his tragic death at age thirty-five. The property was sold and the Atlantic House continued to serve the public through the 1988 season, when it was sold again and torn down to make way for condominiums.

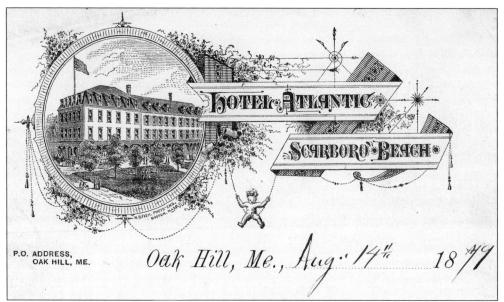

The letter written on this letterhead reads: "Dear Brother, I thought that I would write you a few lines to let you know that I am kicking yet, but very feeble. We have a house full of people this summer and of course all the work comes upon the one that is willing to do his or her part and it makes it pretty hard for me. I have just left off writing to tell some people that we have no room for them. We have got from 125 to 135 and have had them this past month. . .Why don't you come down and see a fellow? . . . Write when you get a chance. —Your Brother, George H. Milliken, Atlantic House" (Courtesy Dino and Barbara Giamatti.)

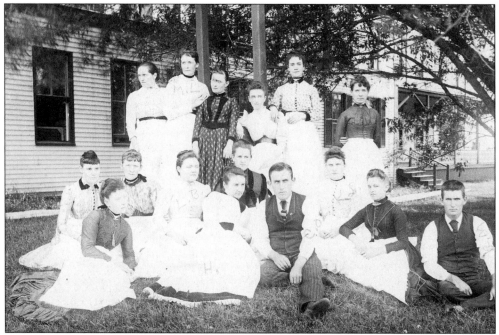

Although not everyone is identified in this *c.* 1879 photograph of the Atlantic House staff, George Milliken, author of the above letter, is seated at the lower right corner of the image.

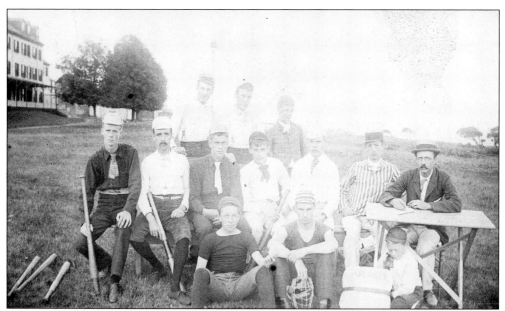

The Atlantic House Baseball Club of 1890 is shown here, complete with manager, umpire, and bat boy. The hotel can be seen at the far left. (Courtesy of Dino and Barbara Giamatti.)

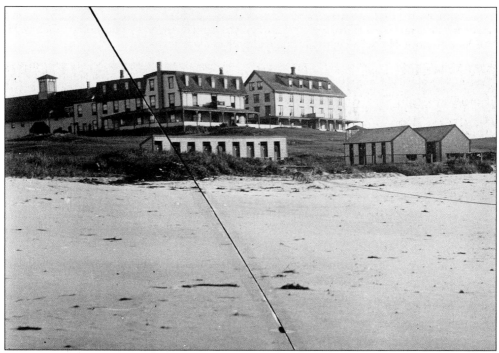

When Rhoda Foss Gunnison died, her will split the Atlantic House property into thirds. On the eastern side of the property, her son James, and his wife built the Kirkwood in the 1870s. The hotel had a short life, closing its doors at the end of the 1905 season. A news article of the day reported that the hotel would be remodeled into a summer home. This never happened and the vacant structure was torn down in the 1920s. (Courtesy Frank Hodgdon.)

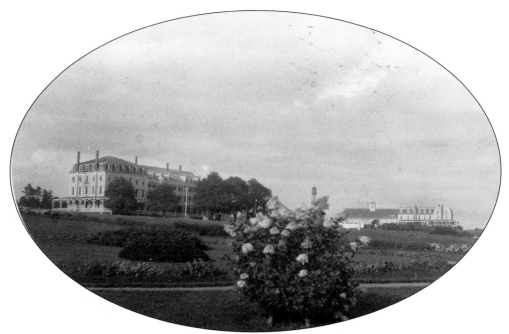

As the Atlantic House and the Kirkwood were competing hotels, they were not photographed together very often. (Courtesy Scarborough Public Library.)

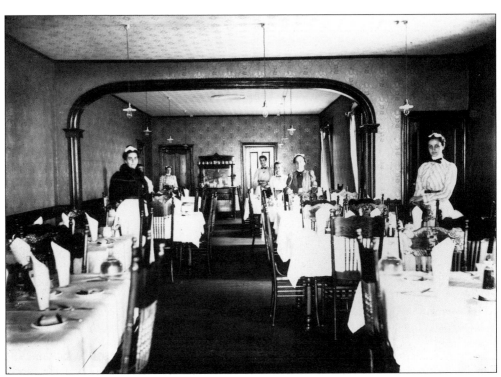

This is the waitstaff and dining room at the Kirkwood.

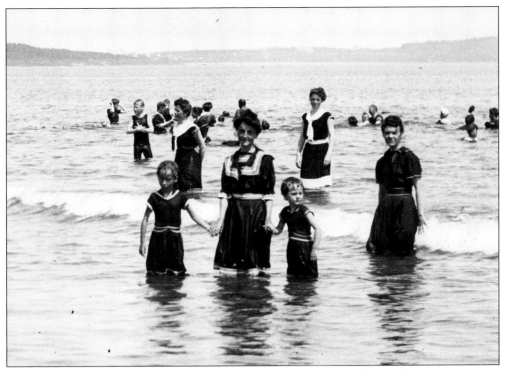

A family bathing at Scarborough Beach is depicted in this *c.* 1900 photograph.

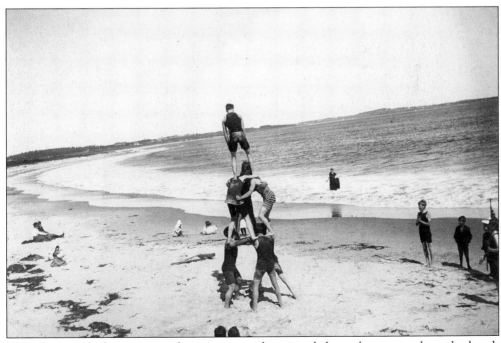

This photograph demonstrates that young people enjoyed themselves as much at the beach ninety years ago as they do today.

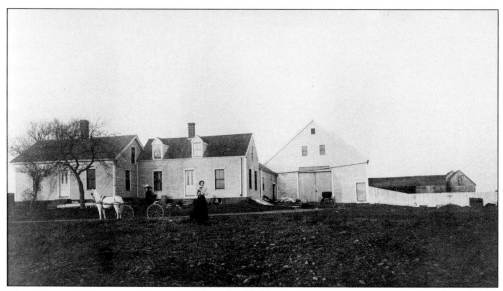

The Newcomb farm was located near the intersection of Spurwink and Black Point Roads. When the barn burned in the 1920s, a completely new set of buildings was erected on this site. The portion of the house behind the apple tree was eventually moved to 184 Pleasant Hill Road.

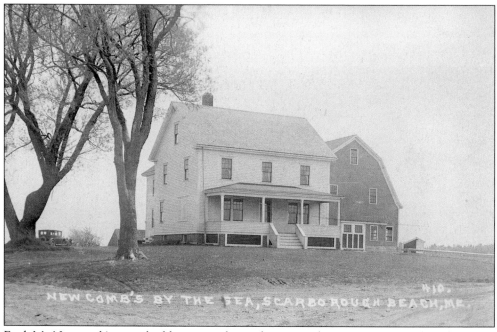

Fred M. Newcomb's new buildings are shown here. At that time, summer boarders were accommodated in the farmhouse, as evidenced by this postcard view advertising "Newcomb's By The Sea."

The Forest House was located on Massacre Pond. It was a popular boarding house until it was destroyed by fire. J. Hartley Merrick of Philadelphia enjoyed staying at the Forest House so much that he bought the vacant property, and in 1927, built himself a summer home.

Gladys Jordan bought the Merrick house in the mid-1950s. She rented rooms there, calling it Prouts Neck Country House. On property across the street from the house she started a parking lot, allowing public access to Scarborough Beach. Not only was Gladys a smart business woman, she was a well-respected school teacher, real estate broker, and political activist.

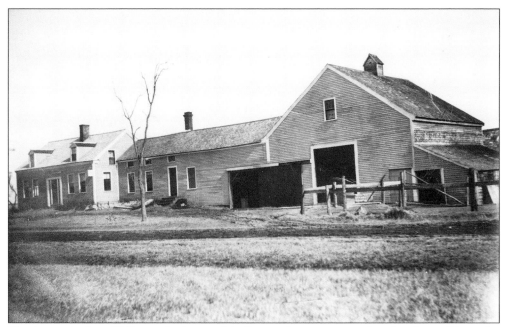

This house, built in 1743, was the home of Ai Seavey for many years. Ai, a brother to Harris the stage coach driver, was a blacksmith and had his shop here. As telephone service expanded, it was the telephone exchange for Prouts Neck. For a time the property was owned by the Spragues and called Massacre Farm. In later years, it has been home to the Lindholm family and their greenhouse business. (Courtesy Cecelia Lindholm.)

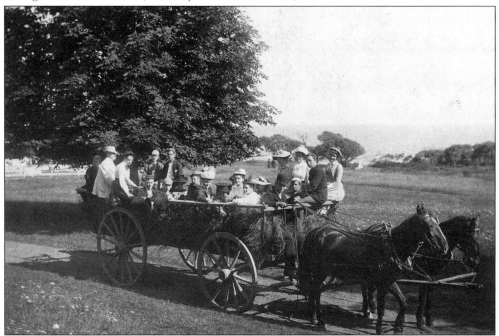

Hay wagon rides were a popular event in the summer. Destinations were often to such places as Mitchell's shore dinner house on the Spurwink River, or Two Lights in Cape Elizabeth. (Courtesy Prouts Neck Historical Society.)

Three
Prouts Neck

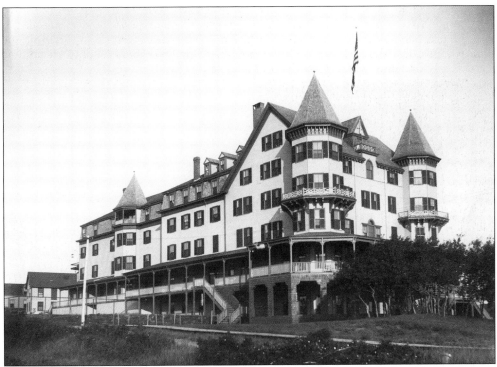

The Jocelyn House was built in 1890 by Frank B. Libby. Originally, it had a long boxy appearance similar to the Southgate Hotel (see p. 47). In 1898, the noted architect John Calvin Stevens redesigned the hotel, changing the roofline and adding the Victorian towers and trim. The five-story hotel had eighty-one guest rooms, generated its own electric power, had an elevator, and offered every comfort that could be expected in its day. It was built on the opposite end of Scarborough Beach from the Atlantic House and Kirkwood Hotel.

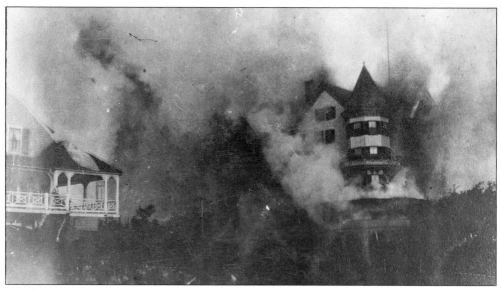

The Jocelyn Hotel was consumed in a dramatic fire that started in the pre-dawn hours of July 27, 1909. Fire broke out in the stable of Alonzo Googins, who had his home and business established between the Jocelyn and Southgate Hotels. The fire raged out of control, burning Alonzo Googins' buildings. The wind swept the flames to the Jocelyn. Had it been blowing in the opposite direction, the Southgate might well have burned. Without an organized fire department, nothing could be done to stop the flames.

When news of the Jocelyn fire reached the Newcomb farm, Mr. Newcomb sent his son Skip (Jessie Harold) to retrieve the vital records from their store, which was located not far from the burning buildings. The young boy rode his bicycle so hard and fast to Prouts Neck that when he got there he had lost the strength in his legs. He was so wobbly, he could barely get from his bicycle into the building. The store did not burn.

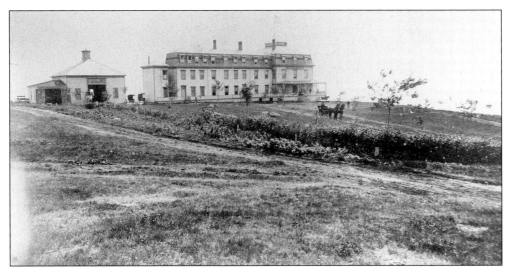

Three days after Christmas in 1876, Tryphena Foss purchased a peninsula of land at Prouts Neck that would become known as Checkley Point. The following year, her son Ira built a boarding house which he named for Samuel Checkley, one of the early settlers in the area. This picture was taken *c.* 1880. (Courtesy Ira Foss.)

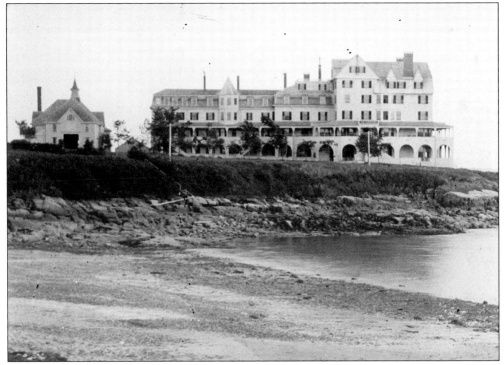

With its commanding location and the management skills of Ira Foss, the hotel was a great success. One of Ira's strengths was his ability to build. The hotel was enlarged and improved many times over the years. With stiff competition from other hotels in Prouts Neck and Old Orchard, every effort was made to please the customers. To quote a 1906 brochure: "The baths are supplied with fresh and salt water, so that any who cannot endure the shock of bathing in these Northern waters can obtain all the benefit of the salt water without leaving the house."

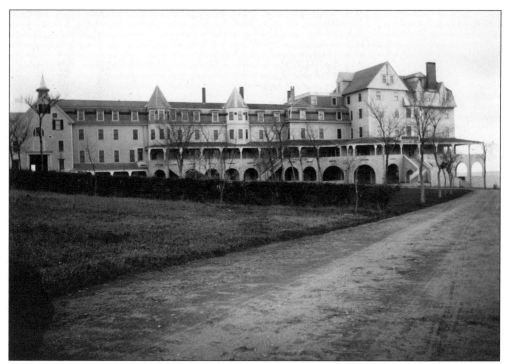

Ira Foss died in 1919 at the age of sixty-three. At the time of his death, the hotel had over eighty rooms, and had seen its last expansion. His widow, Mary Larrabee Foss, carried on the business as long as she was able. In 1941, the Foss family sold the hotel and it was torn down.

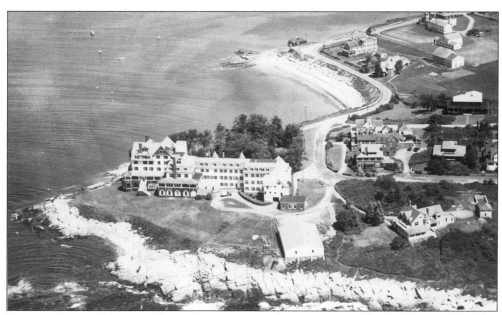

This aerial view of the Checkley lends perspective about position of the building on Checkley Point. As one drives by the location today, it seems hard to visualize how such a large hotel was located there. The Prouts Neck Yacht Club can be seen at the top of the photograph.

Known as the Prouts Neck or Middle House, this was the residence of Thomas Libby. It was located on the western highlands overlooking the Scarborough River. Mr. Libby found he could make money cleaning and cooking the catch for people who were fishing in the river. As time went on, he began to provide lodging, first for fishermen, and then for summer boarders, making this Prouts Neck's first hotel. Eventually the house was cut in two, with one half becoming the Perry House. The other half was moved and became V.T. Shaw's store at Prouts Neck.

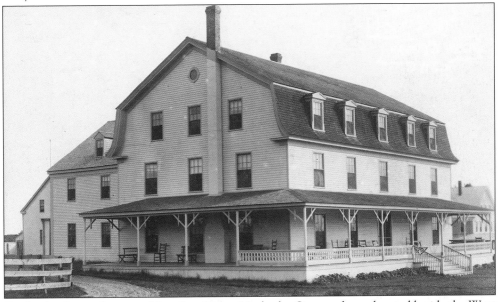

Credited as being the second hotel on Prouts Neck, the Cammock was located beside the West Point House. It was started when Silas Libby gave in to pressure to accommodate summer visitors in his home. Like the Prouts Neck House and the Willows, the Cammock House eventually became a full-scale hotel. It was torn down in the 1960s.

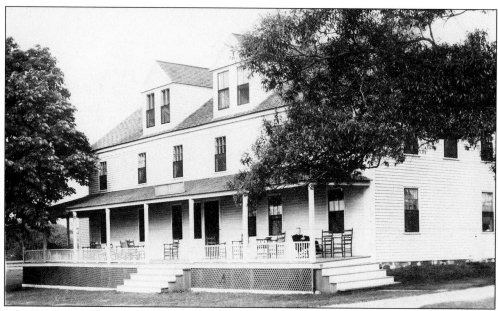

After Thomas Libby's death in 1871, his son Benaiah built this home to the east of the Prouts Neck House. He called his house the Willows, for the many trees lining the road. Like his parents before him, he accommodated summer boarders.

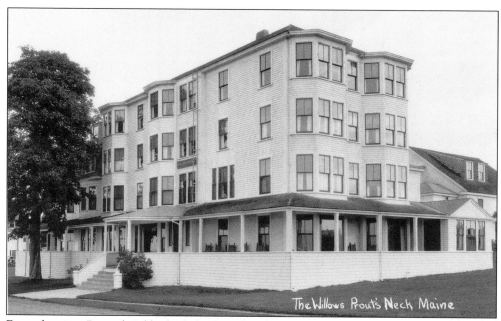

The Willows Prout's Neck Maine

From the time Benaiah Libby built his boarding house in the 1870s, to the time it was torn down some ninety years later, it went through a great transformation. The hotel could accommodate sixty guests.

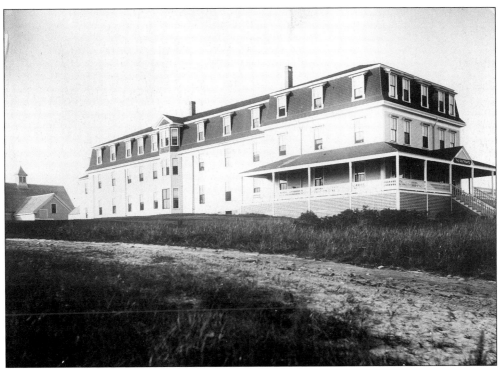

The Southgate Hotel was built in *c.* 1878 by John M. Kaler. It was named for Judge Southgate, who settled in Dunstan and had owned property in the Prouts Neck area.

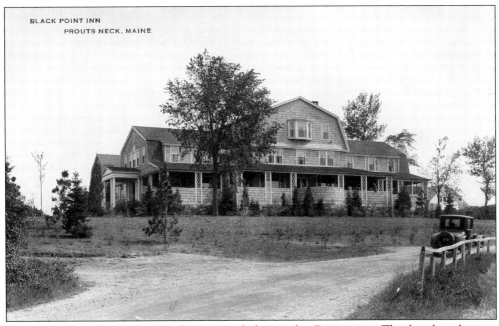

The Kaler family sold the Southgate Hotel during the Depression. The hotel underwent extensive renovation in the 1920s, and the name was changed to Black Point Inn. Of all the hotels that once operated at Prouts Neck, this is the only one that is still in business.

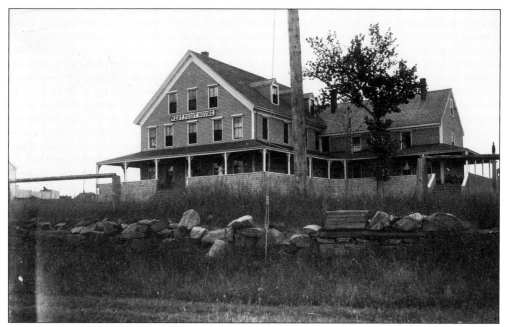

The West Point Hotel was built in the late 1870s by Thomas J. Libby. He was a third generation hotel man, after his father Silas at the Cammock, and his grandfather Thomas at the Prouts Neck House. Thomas J. lost the hotel in 1885, when the bank foreclosed on his mortgage. Robert Jordan was proprietor as early as 1909 and he ran the hotel until *c.* 1930. He continued to live on the property until his death in 1965. The contents of the hotel were then auctioned and the building torn down.

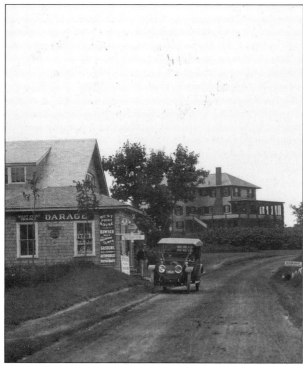

The West Point House Garage was built in 1909 by Robert Jordan. The small wooden structure was later moved near V.T. Shaw's store. The remaining brick structure is known today as West Point House.

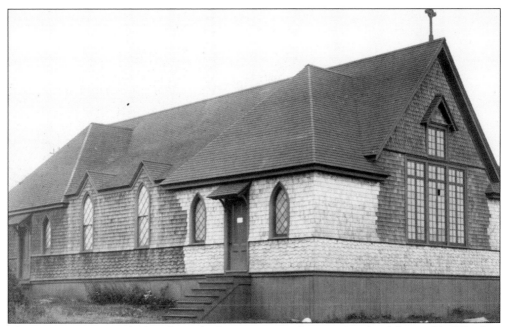

The St. James Episcopal Church was built at Prouts Neck in 1890 on land donated by Winslow Homer's father. Additions were added in 1900 and 1905. Located on Winslow Homer Road, it still serves the community during the summer season.

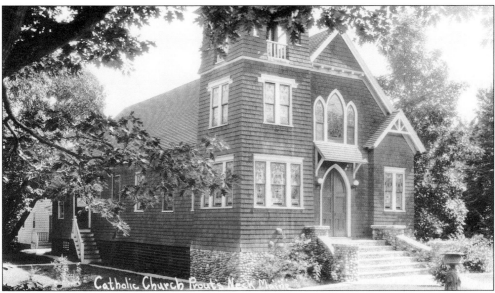

The St. James Catholic Church at Prouts Neck was built in 1907. According to historical documents it was originally built to serve the members of the Irish community that lived and worked at Prouts Neck and Higgins Beach. The church is now privately owned and has been remodeled into a cottage.

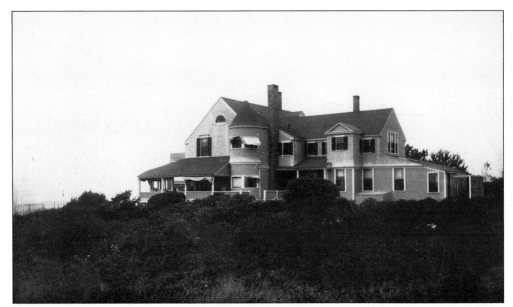

The Ark was the summer residence of the Homer family at Prouts Neck. Charles Savage Homer Sr., Winslow's father, wanted a vacation home where his family could spend time together. With the financial backing of his son, Charles Jr., the house was finished in 1883. Built near the Checkley Hotel, it had a view of the ocean on three sides.

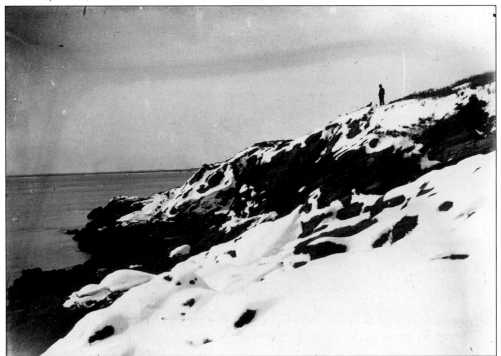

This cliff, on the eastern side of Prouts Neck, was the subject of the 1894 oil on canvas by Winslow Homer called *High Cliff, Coast of Maine*. Taking into consideration the man's stature, the style of his hat, and the small dog, one can't help but wonder if this might be Winslow Homer on a solitary winter walk.

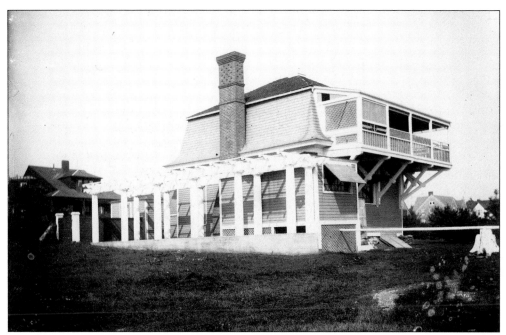

Winslow Homer did not like his quarters in the Ark, so, one year after the house was completed, he had John Calvin Stevens redesign the stable into a studio with living quarters on the second floor. The building was moved a short distance from the house and a new stable was erected for the Ark.

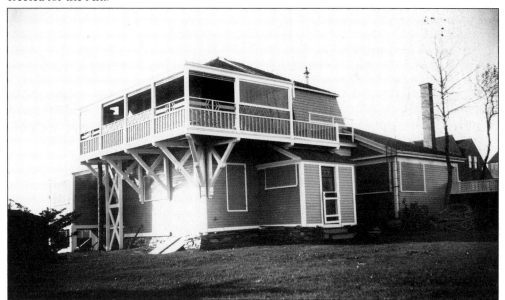

As Winslow Homer's reputation as an artist grew, so did the number of people who wanted to partake of his time. He did not like to be disturbed while at work and the studio afforded him the privacy he needed. Homer drew a line between working and socializing. This gained the artist a second reputation, of being anti-social or reclusive. This was not necessarily the case. The cliché "all things in their own time" may apply. Note the twig-style garden bench in the photograph.

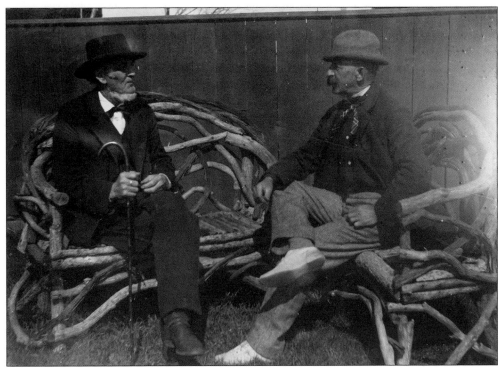

Winslow Homer, with family friend and advisor Frank Coolbroth, are seated on a twig-style garden bench outside the studio. It has been said that when Homer had a visitor he did not wish to stay for long, they sat on this bench, because it wasn't particularly comfortable.

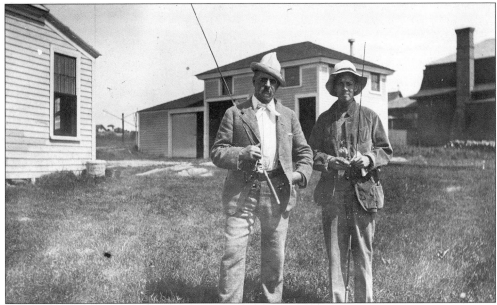

Charles Savage Homer Jr. (left), shown here outside the Ark, developed Valspar, a varnish product still marketed today. He financed the Homer family cottage, the Ark, and the purchase of land from the Libby family for development. He also helped his brother when Winslow was establishing himself as an independent artist. (Courtesy Jane King.)

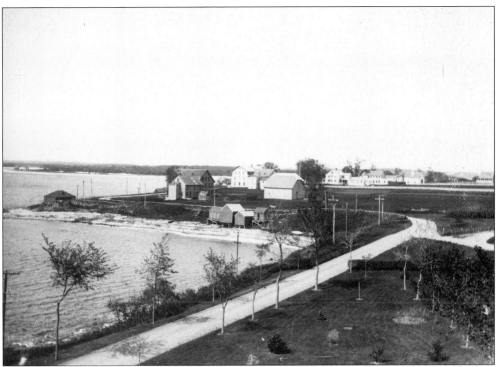

A view from upstairs in the Checkley, looking towards the yacht club. Across the street was the West Point Hotel. This photograph was taken before 1909, as the brick garage (now remodeled as West Point House) had not yet been built.

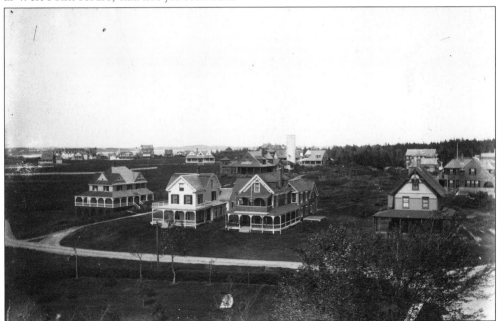

This is a companion view from upstairs in the Checkley. Cottages can be seen all the way across Prouts Neck. In the days of Thomas Libby, before cottage development began, much of the neck was used to pasture sheep. The area that became the sanctuary was the only wooded area.

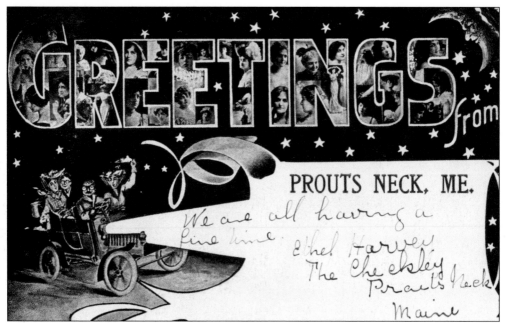

This postcard from Prouts Neck is postmarked 1906.

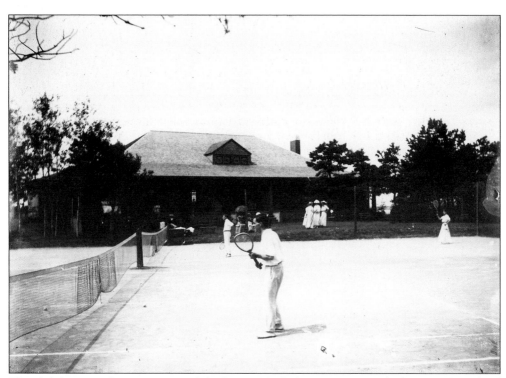

The club house and tennis courts of the Prouts Neck Association were built *c.* 1906, on land that was formerly the Wiggin farm. It is located just before Black Point Inn on the opposite side of the road.

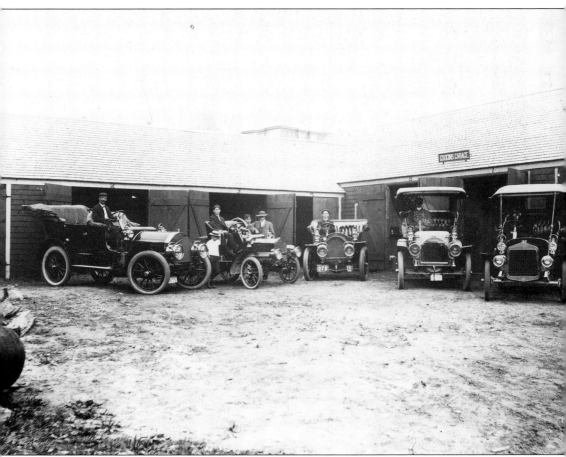

Alonzo Googins operated this automobile garage as part of his business at Prouts Neck. This building, as well as the rest of Alonzo's property, was consumed in the Jocelyn Hotel fire of July 27, 1909. Fortunately, the cars were removed to safety before the fire reached them. There were 300 gallons of gasoline stored in an above ground tank and, fearing explosion, workers turned the fuel out onto to the ground and ignited it.

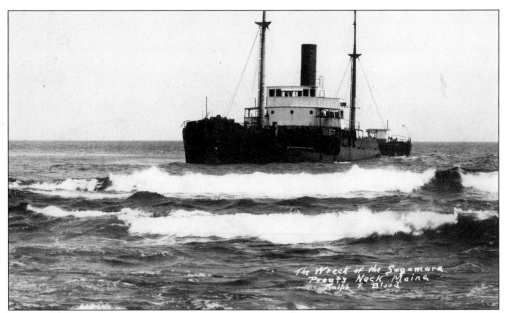

The steamship *Sagamore* ran aground on the eastern ledges of Prouts Neck on January 14, 1934. It departed from Portland in a snowstorm that night en route to Boston. The lookouts tried to pick up the lighted buoy at Willard Point but could not, due to poor visibility. In addition, the light at Pine Tree Ledge was out. The ship struck Corwin's Ledge, 2 1/2 miles off Cape Elizabeth. It was loaded with bolts of cloth, some of which washed up on Scarborough Beach and were salvaged by local families. Attempts were made to refloat the *Sagamore*, but all were unsuccessful.

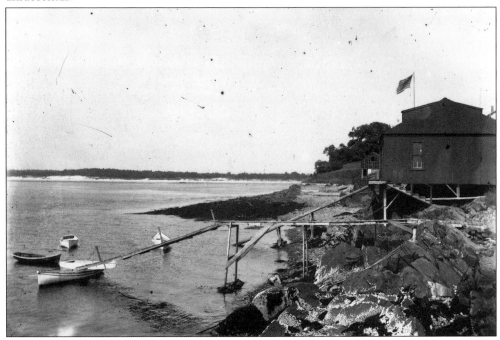

The Prouts Neck Yacht Club was incorporated in 1926. The nucleus of the present-day yacht club building was this boathouse.

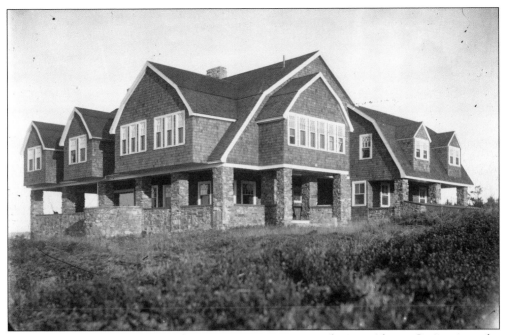

Clipperways is one of Prouts Neck's most impressive summer homes. Alonzo Googins was the contractor, and this structure is a testament to his ability as a builder. The stone for the house was quarried from the eastern edge of Prouts Neck. Originally called Edgecomb, the house was built for Dr. and Mrs. F.B. Stevenson of Portsmouth.

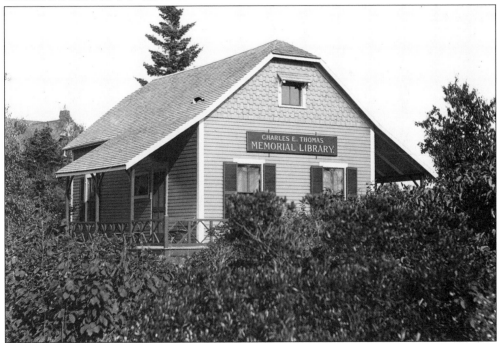

The Thomas Memorial Library was given to the Prouts Neck Association in 1898, as stipulated in the will of Charles E. Thomas. A noted watercolor artist, Thomas built the cottage in 1887 as a studio. It was his wish that the building be used as a library.

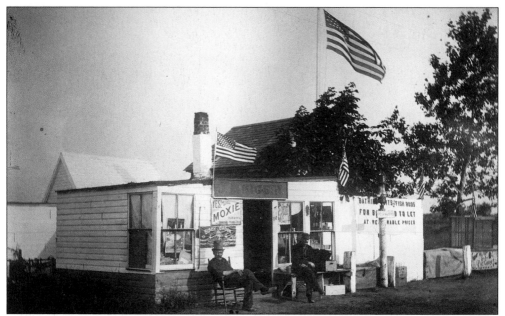

Captain John Wiggin was the proprietor of a small store located on the shore across from the entrance to the Southgate Hotel. A local character, he was a favorite of many visitors to this area one hundred years ago. Wiggin was described as eccentric, and the "captain" in his name stood only for "captain of his domain." Wiggin catered to the needs of the growing summer colony at Prouts Neck. He supplied everything from soft drinks and ice cream to clams and lobster. It was from him that you could rent a dory, bicycle, fishing pole, or clam digger. (Courtesy Jane King.)

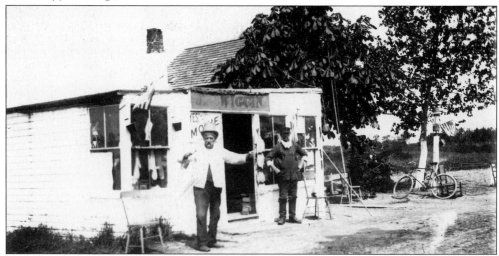

Dressed in his trademark canvas coat and gray top hat, John Wiggin always had time to visit with those who passed by. In fact, this was probably his specialty. He was a particular favorite of children, for whom he would dance and tell stories. Once, he hired an organ grinder with a monkey to perform for their amusement. In this photograph, boot socks can be seen hanging in the window (on the left) and salt fish is tacked to dry by the door (on the right). The store is referenced as a strictly temperate establishment, but some say that individuals could procure drink that was stronger than the Moxie advertised at the front door.

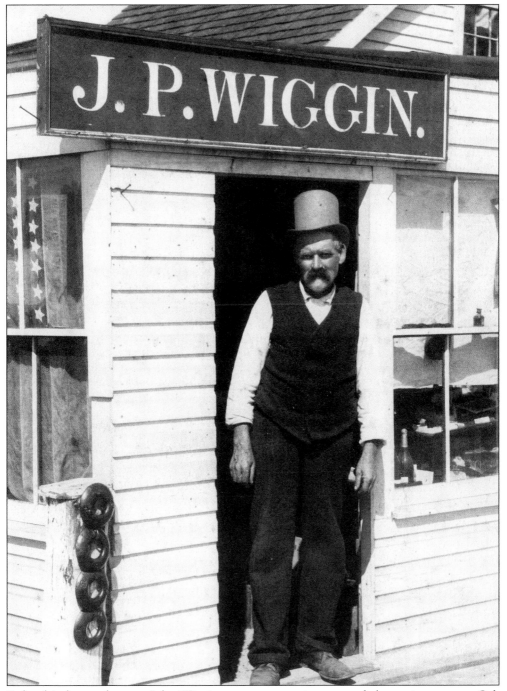

Before his days at the store John Wiggin was postmaster in town and also station agent at Oak Hill Station. He was married once, and he sent his bride to New York City with $500 to buy furniture. When she did not return, he went after her, returning to Scarborough with neither bride nor furniture. He died in 1904, and proof of his popularity is shown by the fact that, two years later, the Portland newspaper ran an article about him, entitled "Captain Wiggin Remembered by Summer Guests." (Courtesy Scarborough Historical Society.)

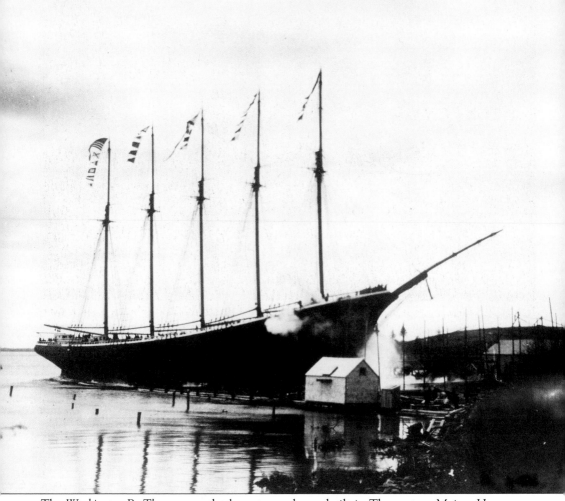

The *Washington B. Thomas* was the largest vessel ever built in Thomaston, Maine. Her career was brief, for just two months after launch, the five-masted schooner was lost in a tragic wreck off Stratton Island. In April 1903, Captain Lermond, with his wife and son on board, set off from Maine loaded with ballast for Virginia. Captain and Mrs. Lermond had recently been married, and she had never been at sea. On June 11, the *Thomas*, on her return trip to Portland, laden with 4,226 tons of soft coal, ran into a fog off Wood Island. The conditions were calm and Captain Lermond made the decision to anchor off the eastern side of Stratton Island. As the wind began to pick up, the ship was found to have dragged anchor. Around midnight the storm intensified, and the captain decided to make sail for deep water to ride out the storm. Before the crew was able to accomplish this, the wind was at gale force and heavy seas were breaking across the ship. (Courtesy Peter D. Batchelder.)

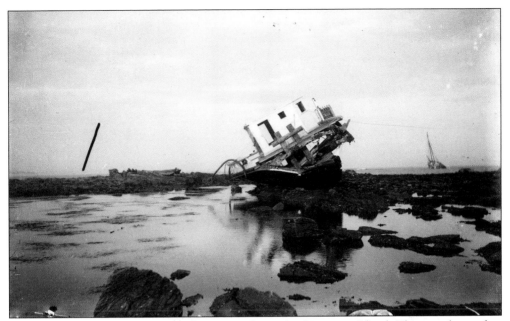

In a short time, the stern of the ship was on the reefs of Stratton Island. The crew knew that their only chance of survival was to climb up in the rigging. The captain pleaded with his wife to leave their cabin, which by now was awash. In fright, she refused, and a falling beam hit the cabin, killing Mrs. Lermond.

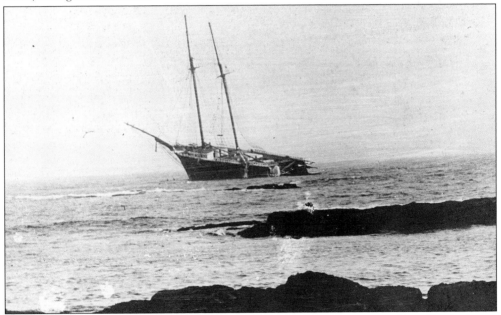

The wreck was not spotted until the next day. The lifesaving station at Cape Elizabeth was notified, but most of the men were on summer vacation, as storms of this magnitude usually occur in the winter months. Volunteers joined the limited crew, and from Prouts Neck they rowed out to Stratton Island in mountainous seas. Nine of the fourteen left on board the *Thomas* were rescued. The seas were so heavy that the remaining five had to spend a second night in the rigging before being rescued. (Courtesy Scarborough Historical Society.)

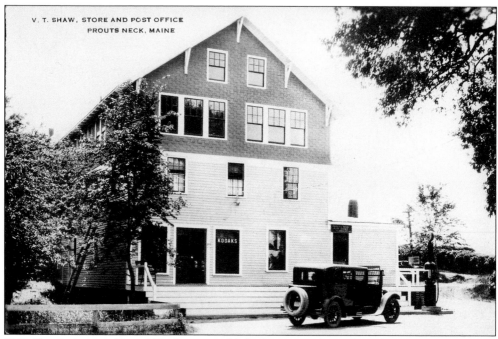

V.T. Shaw's store at Prouts' Neck was established to serve the influx of summer visitors. The seasonal store still operates today, and looks virtually the same as it does in this 1930s photograph.

Fred M. Newcomb operated this seasonal store at Prouts Neck. It was located near Black Point Inn. It was eventually remodeled into a cottage.

Four

Higgins Beach

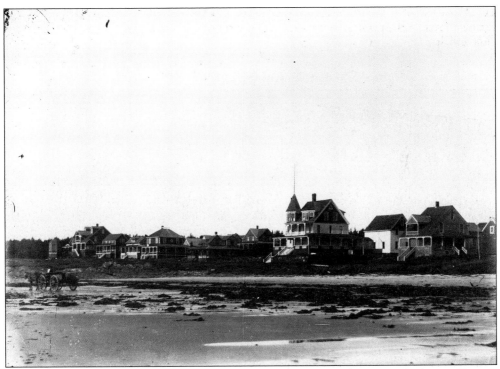

One of Scarborough's first sub-divisions in 1897, a boom in construction took place at Higgins Beach between 1900 and 1910. Most of the early cottages were built by businessmen or professionals, many from Portland, Westbrook, and the Lewiston-Auburn area. The families came for the season and the men would commute to the beach on weekends via the inter-urban trolley lines. Note the farm cart on the beach containing rock weed for fertilizer.

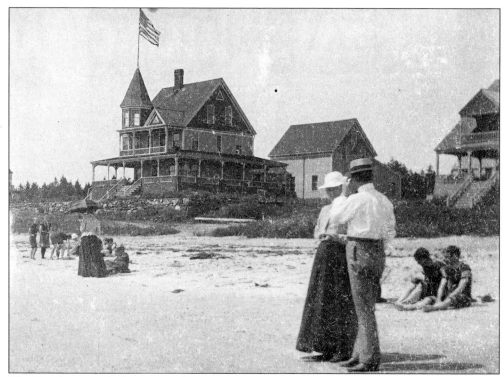

The Breakers was built in 1900 by Portland businessman Frank P. Cummings as a summer home. In the early 1930s, it became a guest house and has accommodated summer visitors at Higgins Beach ever since. The porches were enclosed in the 1940s, and major additions were made in 1964 and 1985.

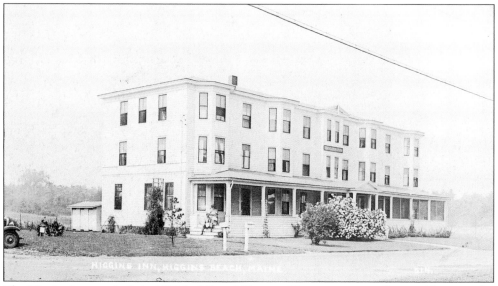

The Higgins Inn was built in 1923 by Edward Higgins. The inn was actually an addition to the eight-room home he built in 1903. The original two-story house was located on the southern end of the newer building. Renamed the Higgins Beach Inn in the 1970s, it is one of the few summer hotels left in the area.

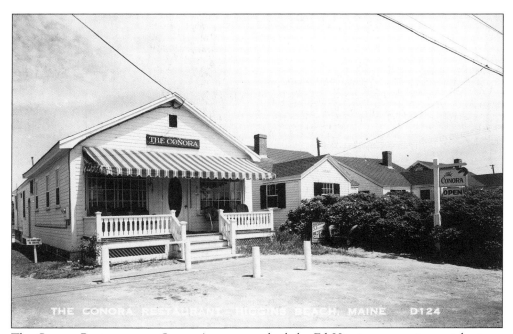

The Conora Restaurant on Ocean Avenue was built by Ed Higgins as a retirement business after he sold Higgins Inn. The name was derived from a combination of the first names of his daughter Constance, and his wife Ora. His son-in-law, Lawrence Harmon, eventually ran the business. The Conora was well known for its fried clams.

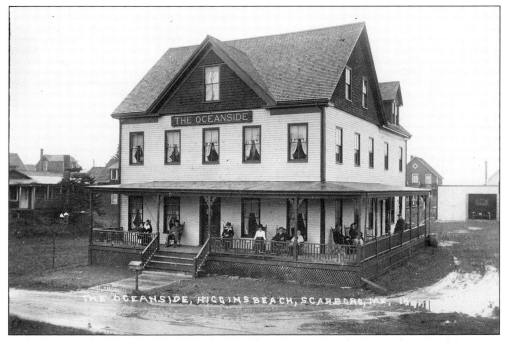

Built in 1897, the Oceanside was the first hotel at Higgins Beach. Located on Pearl Street, it was originally called the Lawson House, after the proprietor. It stands today as an apartment house.

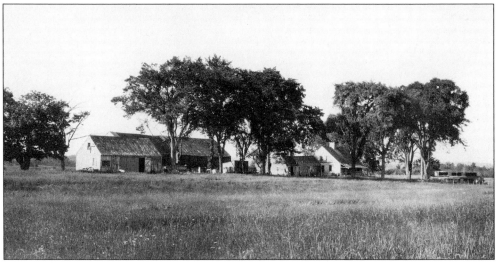

Above: This is a view of the eighteenth-century Higgins Homestead at Higgins Beach. The farmhouse stood at the end of Pearl Street extension.

Below left: The Owls Nest, located at 11 Ocean Avenue, has an interesting history. Estelle Draper, a Portland school teacher, was unhappy that there was no manual training offered at her school. She learned carpentry skills, and eventually built this cottage in 1900 by herself.

Below, right: Al Angel has become a folk hero at Higgins Beach. A native of South Portland, he gave up his job as a trolley conductor and moved here to make his living as a lobsterman. He worked alone, pulling his traps and rowing the dory all by hand.

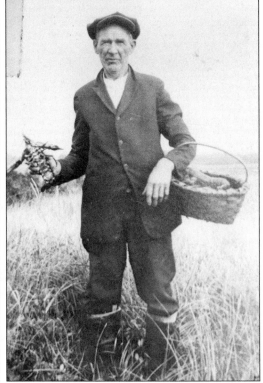

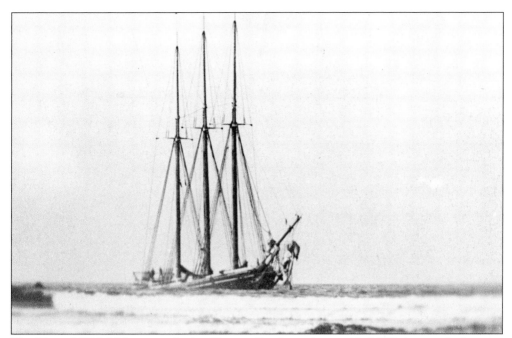

The *Howard W. Middleton* wrecked at Higgins Beach on August 11, 1897. A coastal schooner, the *Middleton* was behind schedule and was sailing at night. In dense fog, the vessel, bound for Portland with a load of coal, strayed off course and struck a ledge in the mouth of the Spurwink River. The fog was so thick that the crew didn't realize there was a community at Higgins Beach and went ashore at Cape Elizabeth. The next day the fog lifted and it was discovered that the ledge had ripped a hole in the vessel below the waterline.

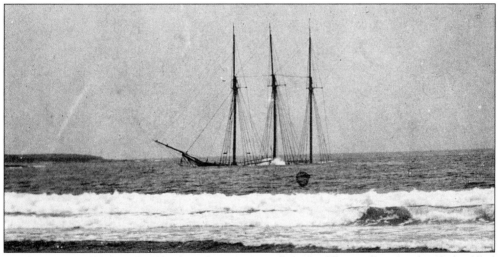

Tug boats came from Portland and tried in vain to pull the *Middleton* off. A few days later, filled with water, the keel broke with the action of the tides, and the vessel was declared a total loss. The *Middleton* was stripped for salvage, and most of the coal was saved. It has been said that the legitimate salvage crew worked by day and a clandestine group worked by night. The group of locals put up enough coal to last three winters. In September of that year, a storm drove the *Middleton* further inland. The remains are still visible on the beach near the bank of the Spurwink River.

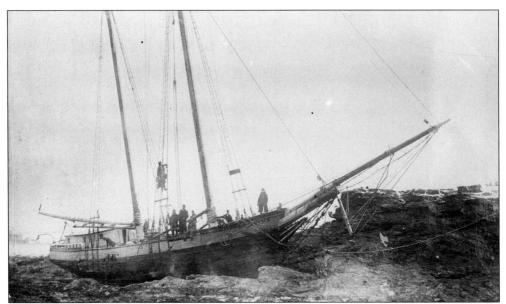

On December 4, 1900, the two-masted schooner *Fannie & Edith* anchored behind Richmond Island to ride out a storm that was intensifying in force. The small vessel put out two anchors, but when the winds picked up to a gale force, the chains parted and the *Fannie & Edith* was at the mercy of the storm. The vessel was swept across Saco Bay, and the crew could only watch as they neared the area known as Hubbard Rocks between Higgins and Scarborough Beach. (Courtesy Prouts Neck Historical Society.)

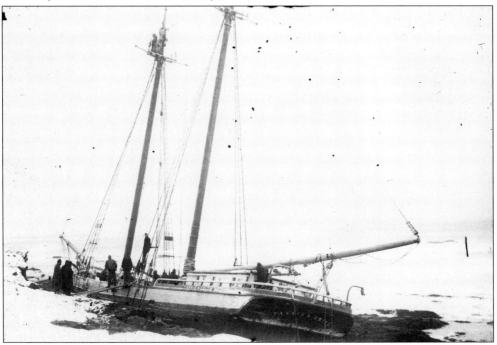

Fearing they would be smashed to pieces, it was nothing short of a miracle when a large wave picked the *Fannie & Edith* up and placed it in a crevice high up in the rocks. The crew quickly ran out a plank and scurried to shore.

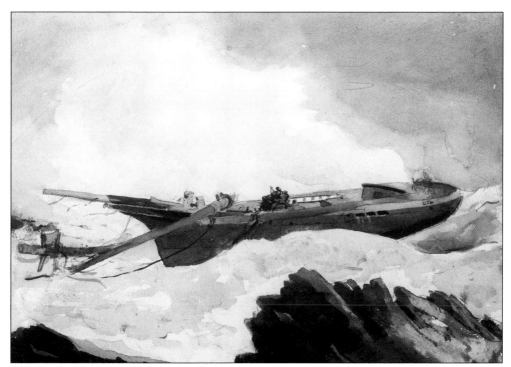

The Wrecked Schooner was Winslow Homer's last watercolor, painted in 1908. It has been said that he was inspired by the wreck of the *Washington B. Thomas.* This may be the case, but the physical model closely resembled the *Fannie & Edith.* Unfortunately, the artist did not leave any written notes on the background of the painting. (Courtesy St. Louis Art Museum.)

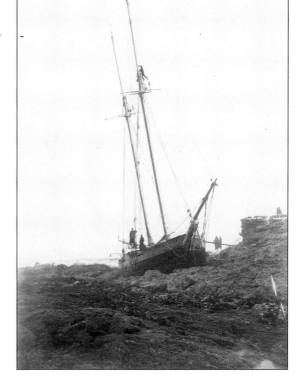

When the tide receded, the *Fannie & Edith* was left high and dry. It was declared a total loss. Photographs taken the following summer show that a salvage had taken place—the vessel had been stripped to the keel. (Courtesy Prouts Neck Historical Society.)

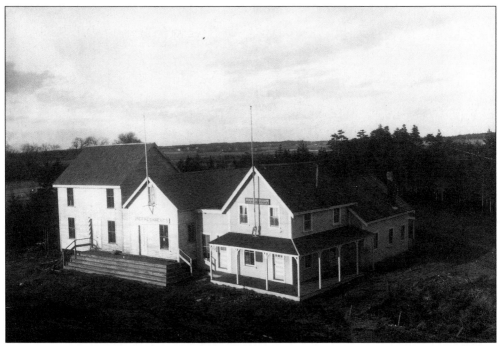

The first store at the beach was called the Higgins Beach Grill. Located on the corner of Greenwood and Ocean Avenue, it included a bowling alley, barber shop, store, and restaurant. It burned in 1902. (Courtesy Scarborough Historical Society.)

The replacement for the Grill was called the Pavilion. It was built the following year in the same location, and served as general store, soda fountain, and bowling alley. It was torn down in 1960.

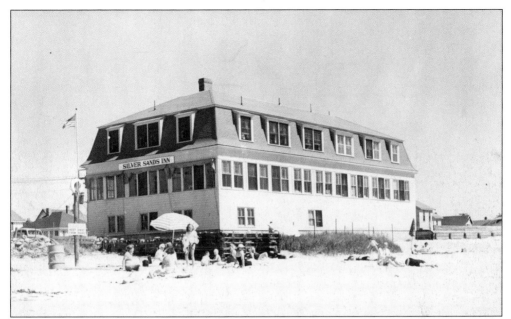

The Silver Sands was built as a summer cottage by Dr. Loring S. Lombard, c. 1907. Originally much smaller, it evolved into a summer hotel, renting rooms and serving meals. Eventually it was converted to efficiency units. There were six individual cottages also on the property. In 1978, a winter storm severely damaged the front of the building and it was torn down.

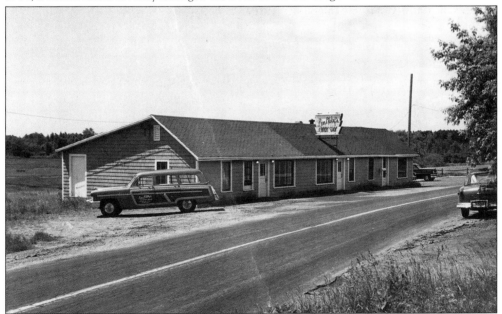

Len Libby (1871–1961) was born at Prouts Neck. His father was the proprietor of the West Point Hotel. The family moved to Portland when Len was twelve and at age thirteen he began his candy-making career. He learned the trade by working for several different firms, but had to quit for health reasons. It was at this time that he bought a 135-acre farm at Spurwink and set out to be a market gardener. This did not last long before he re-entered the candy-making trade, building this candy shop across from his residence. (Courtesy Joan Deering.)

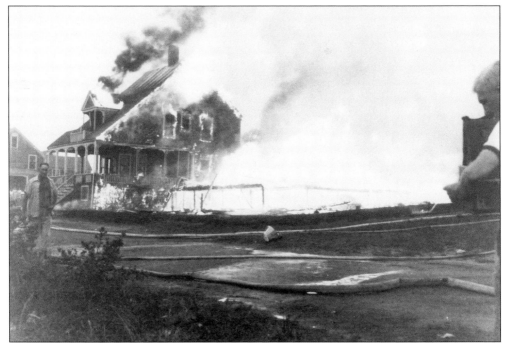

In August 1944, fire struck on Bay View Avenue. The Caskey cottage, on the corner of Ocean Avenue, sustained heavy fire damage, but was rebuilt. The cottage of Dr. and Mrs. Morton (to the right) had already been consumed by the time this picture was taken. The fire started in the Morton cottage, and was caused by a tenant who was trying to fill a kerosene-burning hot water heater. (Courtesy Mildred Thompson.)

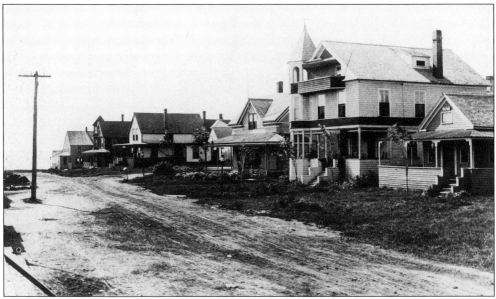

Ocean Avenue, looking toward the waterfront. The second building was called the Towers. It was a boarding house built by Walter Higgins. Looking closely, a cross street can be seen running in the direction of Houghton Street. Cross streets were not on the sub-division plan and were eventually discontinued. The Towers was destroyed by fire.

Five

The Pleasant Hill Area

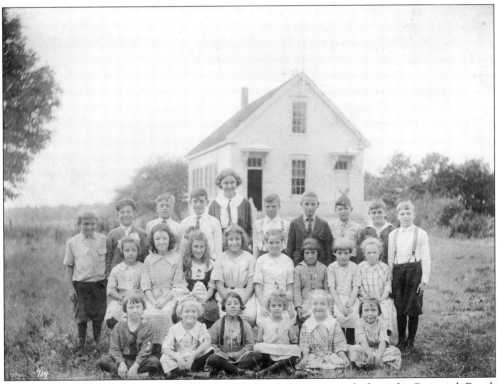

Beech Hill School was located on Pleasant Hill Road about one mile from the Spurwink Road. Students in this c. 1922 photograph are, from left to right: (front row) Marguerite Prout, Marjory Mitchell, Evelina Lorfano, Cora Jenkins, Dorothy Beckwith, and Eleanor Stanford; (middle row) Charlotte Stanford, Evelyn Beckwith, unknown, Dorothea Libby, Emma Jenkins, Elenor Lorfano, Phyllis Libby, Doris Prout, and Leroy Prout; (back row) Frank Mitchell, Ralph Lorfano, Stanley Pederson, Howard Mitchell, Ms. Shortill, Cliff Prout, John Libby, Norman Morse, and Arthur Mitchell. (Courtesy Scarborough Historical Society.)

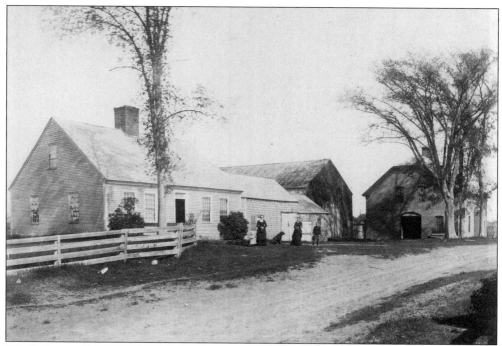

The Robinson Homestead was located on Pleasant Hill Road near Fogg Road. The Robinsons purchased the house and 75 acres in July 1826 for $1,000. Charles Robinson built the brick barn c. 1870 when the brickyard, in which he was a principal, closed. He recovered a portion of his investment by taking the company's inventory. (Courtesy William Littlejohn.)

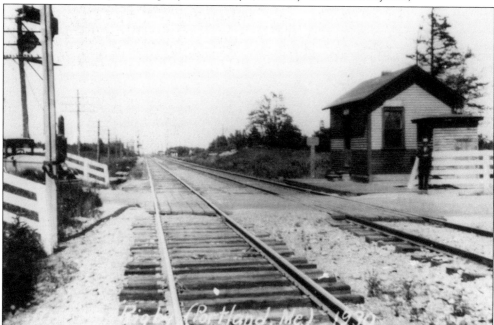

Rigby Crossing was the intersection of the Western Division of the Boston & Maine Railroad and Pleasant Hill Road. Eventually, overpasses were built here and at the crossing on Pine Point Road.

This house, referred to as the Peterson homestead, was actually built for the Larrabee family in 1857. It is located on the corner of Pleasant Hill Road and Highland Avenue. A. Jasper Willey bought the house in 1925, and it remained in his family until recently.

Lena Walker (left) was from the Peterson family. Her parents had immigrated from Germany. One of her brothers, Elliott Peterson, was a prominent Portland automobile dealer on Forest Avenue. The woman on the right is unidentified. (Courtesy Jane King.)

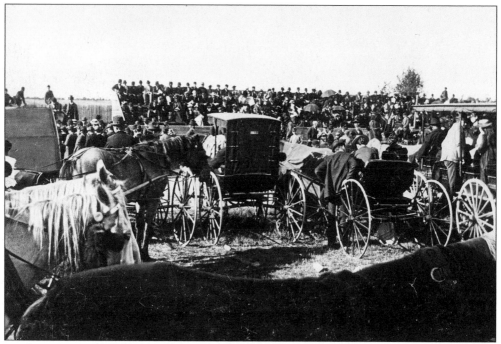

Scarboro Fair was an agricultural fair held from about 1875 to 1900. The actual name was the Scarboro and Cape Elizabeth Fair, but it was never called by that name. The fairgrounds were on the Nutter property, roughly from Engine 3 Station to Pleasant Hill School.

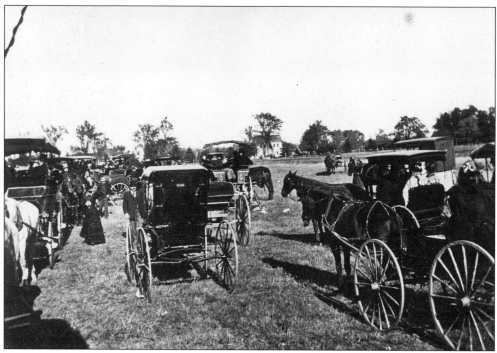

The Benjamin Larrabee homestead, on the corner of Pleasant Hill Road and Highland Avenue, can be seen in the distance in this photograph of carriages at the Scarboro Fairgrounds.

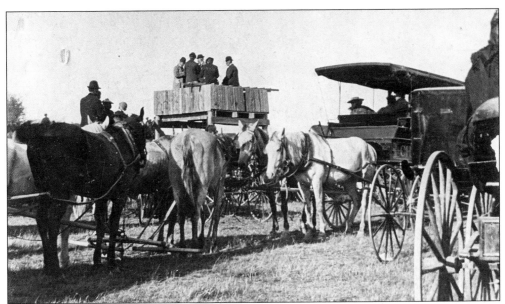

In the early years of the fair, the judges stand was open. The judges climbed a ladder and pulled it up after them. Later, stairs and a roof were added. When the fair broke up, the stand was moved to the Robinson Farm and used as a summer house.

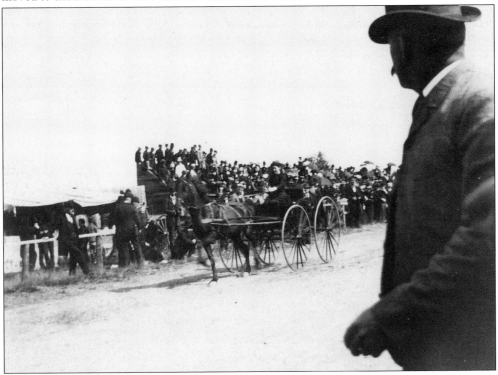

People came to the fair from all over, and the trains made a special stop at the bottom of Pleasant Hill. The main event was horse racing, held on an oval track. Facing the track was a grandstand that backed up to Highland Avenue. There was a ladies' driving event, and it is said there were a few side bets placed. (Courtesy Scarborough Public Library.)

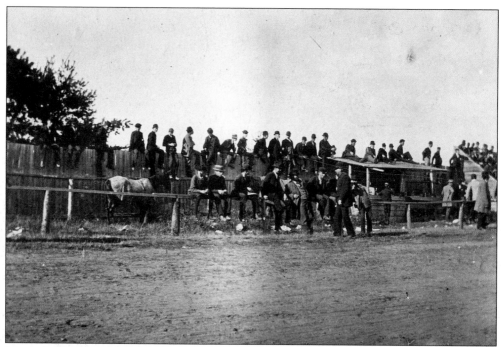

The ladies exhibited fine handwork, quilts, and preserves. Farm animals were shown and oxen pulled in competition. Cabbage was a major crop in this area, especially in Cape Elizabeth, and it was shown along with other vegetables and farm products. There were peddlers who sold fruit, popcorn, and soft drinks.

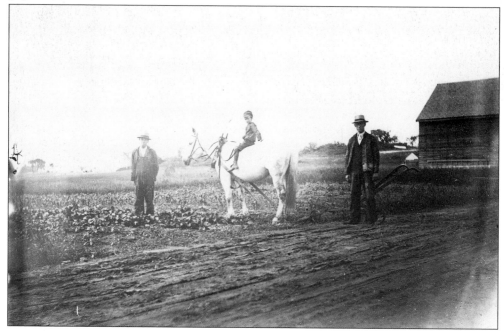

From the time Scarborough was settled until well into this century, much of its economy was based on agriculture. One by one, family farms have been sold for development, until only a handful remain. The identities of the two men and boy are unknown.

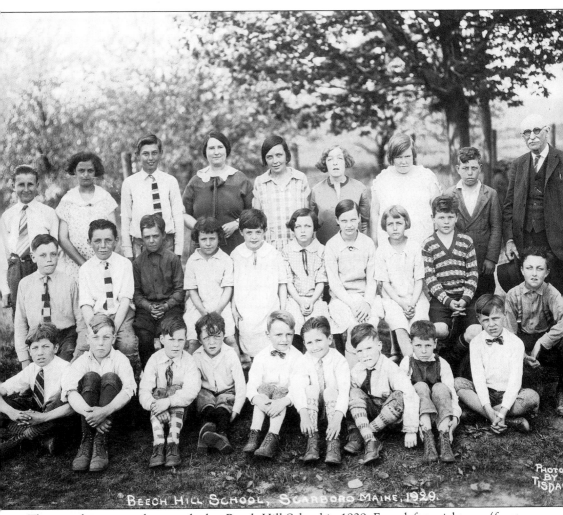

BEECH HILL SCHOOL, SCARBORO MAINE, 1929.

PHOTO BY TISDA

These students were photographed at Beech Hill School in 1929. From left to right are: (front row) Fred Lorfano, unknown, Lawrence Dempsey, George Beckwith, William Littlejohn, Richard Woodard, Lester Dempsey, Lester Perkins, Richard Libby, and Wallace Beckwith; (middle row) Harold Prout, George Stanford, Milton Brakett, Marion Stanford, Barbara Willey, Eleanor Beckwith, Inez Morse, Edith Stanford, and Elwood Mitchell; (back row) George Woodward, Cora Jenkins, Jim Small, Beatrice Berry (teacher), Eleanor Stanford, Dorothy Beckwith, Dot Prout, Lewis Chandler, and superintendent F.H.B. Heald.

Franklin H.B. Heald was the superintendent of Scarborough schools for thirty-three years, from 1913 to 1946. He was also superintendent of Old Orchard from 1914 to 1931. He did not drive and would walk between the one-room schoolhouses. Beatrice Berry married Albert Gantnier and they made their home on the Broadturn Road. (Courtesy Eleanor Lorfano.)

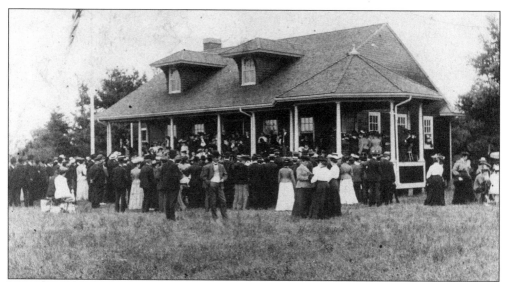

The Odd Fellows' Casino was built across from the present-day location of Humpty Dumpty Potato Chips. Dedicated in 1904, it was a gathering place for members of the seven Odd Fellows Lodges of Greater Portland. The Odd Fellows is a beneficial fraternal order, popular at the turn of the century. The decision to build at this location is an example of the development that took place as a direct result of the trolley service through Scarborough.

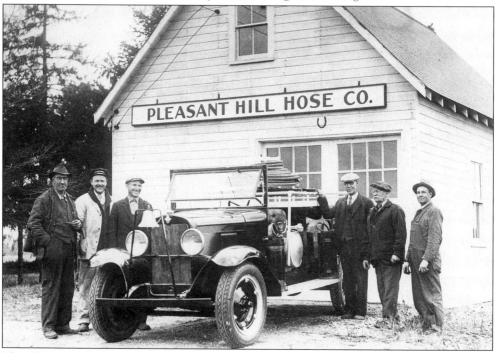

The Pleasant Hill Hose Company was established in the 1920s. Company members built this truck, which they called a "chemical & hose wagon" out of a *c.* 1930 Chevrolet automobile. From left to right are Winfield Prout, Bob Nutter, Laurits Jensen, Orin Maloney, Colonel Charles Nutter (he attained his rank in the Spanish American War), and Neiles Jensen. (Courtesy Scarborough Engine 3.)

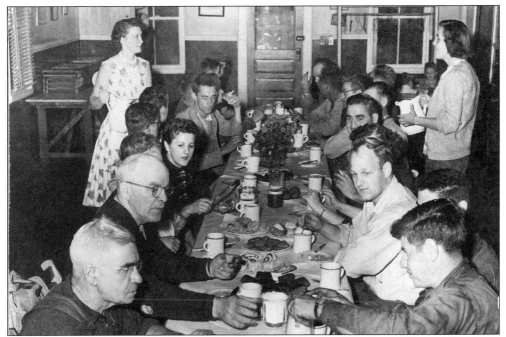

Coffee and doughnuts are served at the Pleasant Hill Fire Station to benefit the Jimmy Fund. Neighborhood ladies volunteered the labor and the baked goods. This photograph ran in the *Evening Express*, on September 20, 1956. The four men seated in the foreground at the table are, clockwise from the lower left: Jasper Willey, Bob Nutter, Van Coulthart, and an unidentified man. (Courtesy Scarborough Engine 3.)

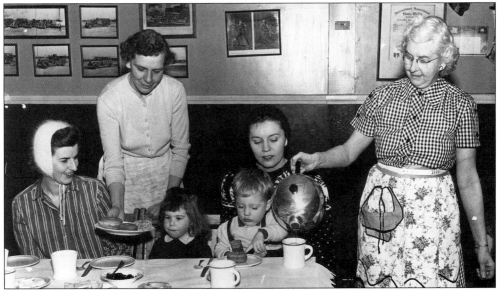

Women of Engine 3 Auxiliary are shown here, serving coffee to benefit the March of Dimes. The customers are, from left to right: Mrs. Edward Connelly, Jean Marie Connelly (age three), Mrs. Rudolph Violette, and David Ryder (age two, the son of Forrest Ryder). Serving are Mrs. William Woolfe (left) and Mrs. Jasper Willey. This photograph ran in the *Portland Evening Express*, on January 18, 1958. (Courtesy Scarborough Engine 3.)

Located along Spurwink Road east of Higgins Beach, this house is on the high ground overlooking the Spurwink River. Built *c.* 1717, it was a roadside inn called Tavern on the Hill. It has been home to several generations of the Stanford family. (Courtesy George Stanford Sr.)

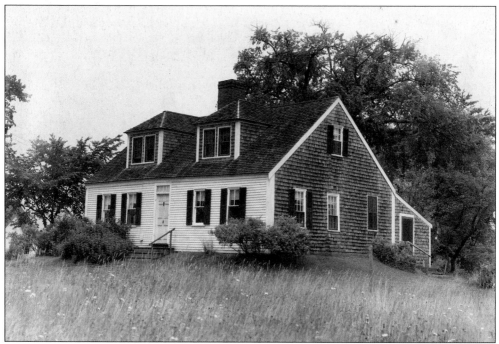

Another house at Spurwink, the Small Homestead, was built in 1765 by Samuel Small. It is located near the end of Pleasant Hill Road. This photograph was taken *c.* 1930.

Six

In the Vicinity of Oak Hill

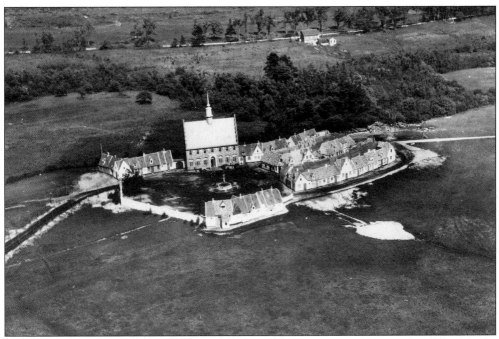

Den Danski Lansbe, the Danish Village, opened to the public in 1930. It was a first-class motor court built by Portland hotel-man Henry Rines. The one hundred-unit complex was probably the finest set of buildings, built on a theme, ever erected in the state. Architect Peter Holdensen, who had designed the Danish Tea Room for Rines at the Eastland Hotel in Portland, was the architect for the project. He designed the Danish Village to reflect the architecture in Ribe, a village in his native homeland of Denmark. (Courtesy Scarborough Historical Society.)

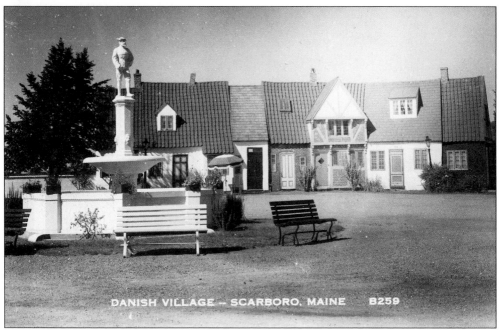

DANISH VILLAGE — SCARBORO, MAINE B259

A statue of Niels Ebbenson, the Danish patriot of 1340, stood on the fountain in the central square. Meals were served in the main building, known as the Raadhus. The outbreak of World War II led to the slow decline of the Danish Village. It was leased to the government as housing for shipyard workers in South Portland. The Rines family sold the property in 1947 and it steadily declined, plagued by mismanagement. After several fires, the remaining buildings were eventually torn down.

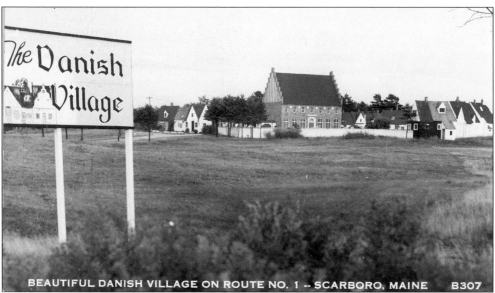

BEAUTIFUL DANISH VILLAGE ON ROUTE NO. 1 — SCARBORO, MAINE B307

In a day when individual cabins were popular, the adjoining-room-style of the Danish Village was a new concept. The idea would lead to motel-style architecture. Great care was given to detail, and no two units were designed the same way. Each was unique in the placement of windows, doorways, and roof design. Roof tops were designed to sag so as to be authentic.

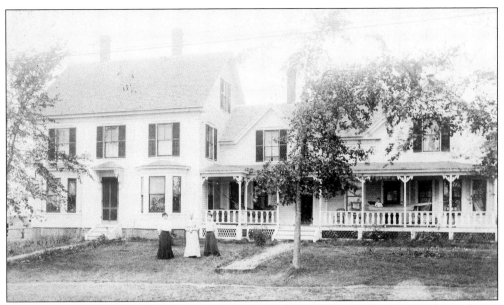

Telephone service was introduced in Scarborough in June 1905. The King home, located next to the old town hall, was Scarborough's first telephone exchange. All calls were routed through this exchange, known as Scarboro Central. Several families were connected on a party line, and the number of rings determined who the call was for. The house was torn down shortly after the demolition of the old town hall and a credit union was built on the property. (Courtesy Robert Domingue.)

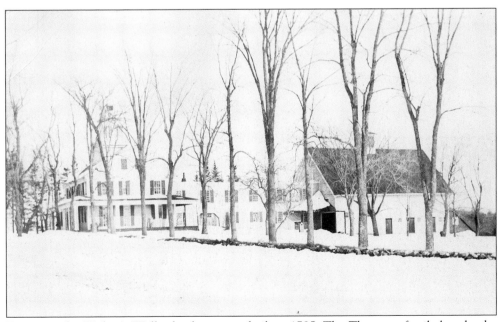

Known as the Widow's Walk, this house was built c. 1785. The Thornton family bought the property in 1825 and lived there for many years. It was also the residence of F.H.B. Heald, the longtime superintendent of Scarborough schools. (Courtesy Margaret Small.)

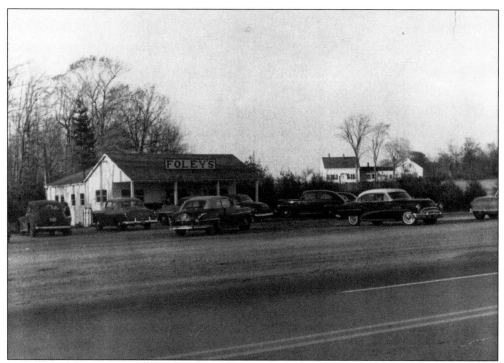

Foley's Ice Cream was a Scarborough landmark for many years. Francis Foley established his business in 1948. In those days, an ice cream cone cost a 5¢. The Foley home can be seen in the background. Shop 'n Save Plaza is now located on this site. (Courtesy Richard Foley.)

This is the Oak Hill intersection in the 1950s, looking down Gorham Road. The cabins shown here were operated by A.S. Lyons.

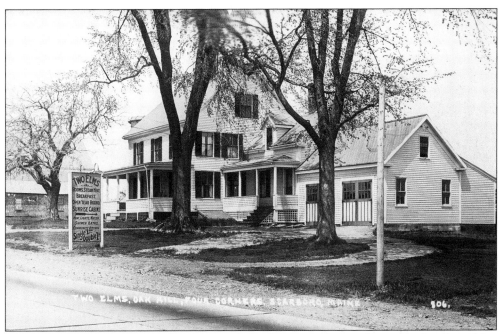

Two Elms at Oak Hill's four corners is typical of many private homes that opened to the public. As automobile travel increased, overnight cabins began to be built, especially along Route 1. A.S. Lyons was the proprietor of this guest home. The house was eventually moved to Gorham Road. Burger King is now located in this site.

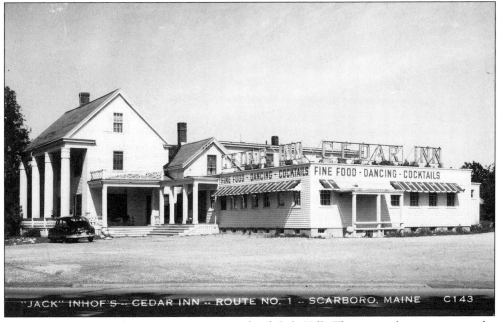

Cedar Inn was located on Route 1, just north of Oak Hill. The original structure was the Samuel March Tavern of the Revolutionary War era. March was a colonel in Washington's army. The business burned in April 1958.

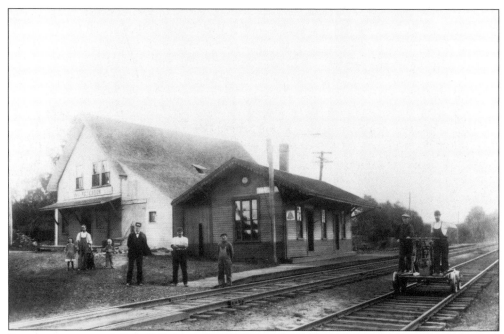

Peterson's store and Oak Hill Station were located on Black Point Road. The tracks were eventually removed, and the railroad bed became Eastern Road. After the store was torn down, the site was vacant for many years. Recently, a duplex was erected there.

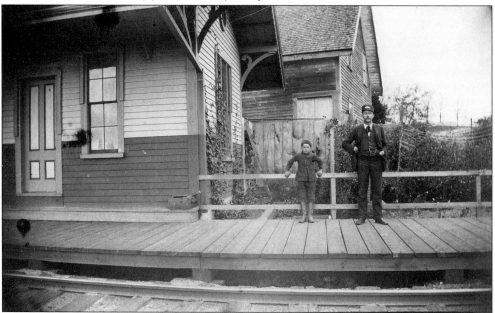

Fred Walker was a younger brother to Charles. Like Charles, he had a long career with the Boston & Maine Railroad. For a time, he was station agent at Oak Hill Station. He was married to Alice Plummer and they had three daughters: Grace, Dorothy, and Florence. They made their home on Pine Point Road. A naturalist, Fred was also interested in photography, and he photographed birds, plants, and other wildlife. He is shown here with Everett Staples, a young local boy who liked to hang around Oak Hill Station.

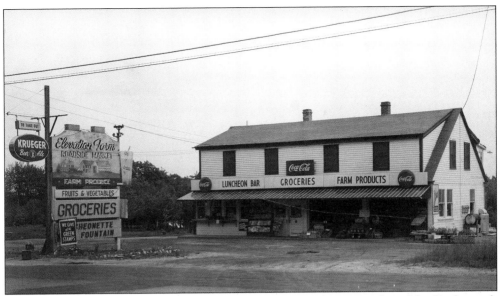

Elevation Farm Market was built on Route 1 by George Douglass, a member of the Scarborough High School Class of 1931. He married into the Laidlaw family, who owned Elevation Farm on Hunnewell Road off Maple Avenue. The building, located near the Scarborough entrance to Route 295, has served as a store, and most recently, as a restaurant.

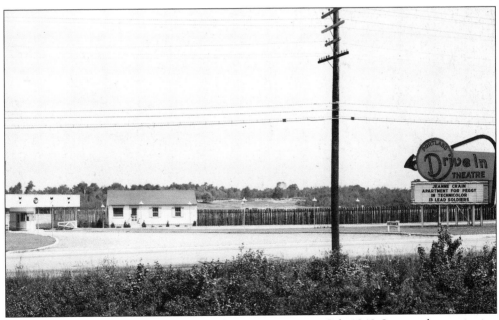

The Portland Drive-In was the second in the state, opening in July 1949. It is worth mentioning that the Baptist Church sponsored services there on Sunday mornings from the mid-1950s until the mid-1970s. In 1968, a second screen was added, but as time went on business declined until the theater closed in 1986. (Courtesy Robert Domingue.)

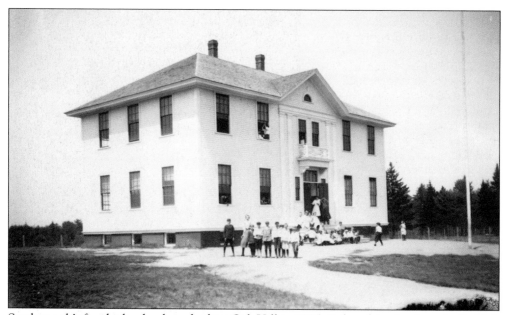

Scarborough's first high school was built at Oak Hill in 1905. Before this school was built, high school classes were held at the town hall. After it was replaced as the high school, it was used as a grammar school. Eventually the town sold the property.

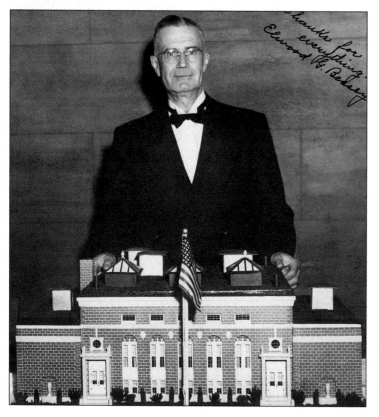

Elwood Bessey was principal of Scarborough High School for thirty years. At his retirement in 1948, he was photographed with a model of the school that, six years later, would be named in his honor. The Bessey School was Scarborough's high school from 1927 until 1954. (Courtesy Scarborough Historical Society.)

These members of the 1921 Scarborough High School track team are, from left to right: (front row) Ross Sherwood, captain Emmons, Thomas Seavey, and Clarence Peterson; (middle row) Arthur Pillsbury, Clayton Sargent, Fred Skillings, and principal and coach Elwood Bessey; (back row) Clark Libby and Edgar Milliken. (Courtesy Scarborough Historical Society.)

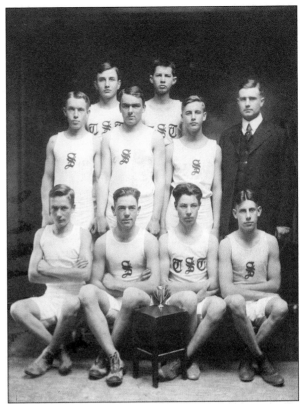

The Free Will Baptist Church was erected at Eight Corners in 1843. It was commonly called Buggy Meeting House. The name was corrupted over the years from the family name of John Burghy, who lived in the house behind the church. That house became Eight Corners Store. (Courtesy Robert Domingue.)

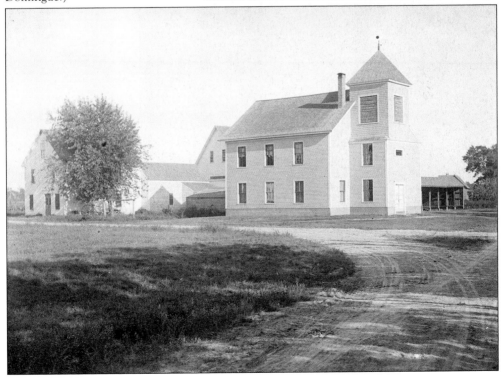

The Samuel Manson Libby house on Libby Road is one of the oldest in Scarborough. The earliest part of the structure was built before 1690. When Scarborough was abandoned in that year, the Indians set fire to the house, but the fire went out before destroying the entire building. About twenty years later the structure was rebuilt and occupied as a homestead. (Courtesy Scarborough Historical Society.)

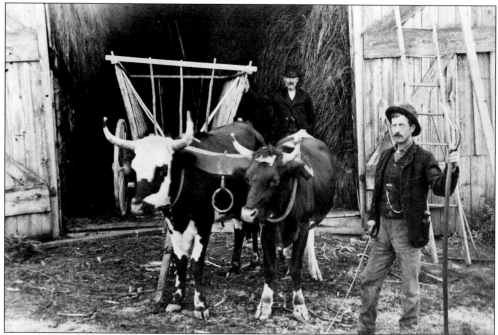

Putting in hay at the Libby farm are Samuel Manson Libby and William Libby. Some years later, because of its proximity to the Scarborough Airport, red lights were mounted on the barn roof. (Courtesy Scarborough Historical Society.)

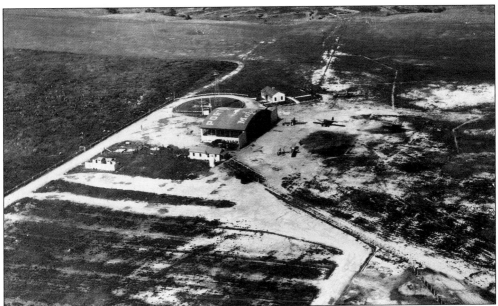

Scarborough Airport was developed by the Portland Chamber of Commerce in 1927 as the municipal airport for the Greater Portland area. Its actual name was the Portland Airport. By today's standards the facility was primitive, consisting of a hangar and a few small outbuildings with a hard-packed clay runway. In 1927, Charles Lindbergh landed here in the *Spirit of St. Louis* while touring the United States after his famous solo flight across the Atlantic in May of that same year. The airport closed during World War II. Today the site is home to the Scarborough Industrial Park. (Courtesy of Scarborough Historical Society.)

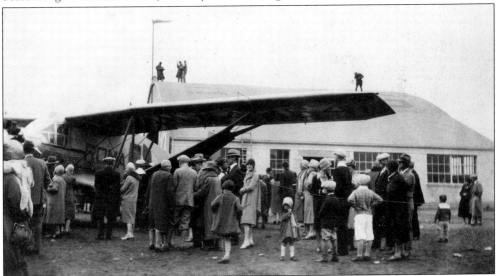

Cesare Sabelli, an Italian World War II ace, wanted to fly the Atlantic non-stop to Rome. A crew of four took off in the *Roma* from Old Orchard Beach on September 19, 1928, but the plane developed problems with the carburetor and they were forced to return. The *Roma* made several trips between Old Orchard Beach and the Scarborough Airport (shown here) while the problems were being worked on. They never made the transatlantic crossing as planned. (Courtesy Scarborough Historical Society.)

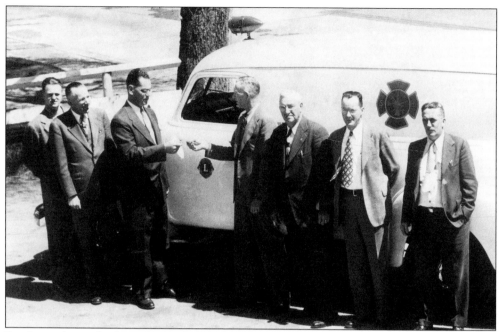

Scarborough was the first town in the state to have a volunteer rescue unit. The 1952 Chevrolet panel truck was donated by the Scarborough Lions Club. At the key presentation ceremony were, from left to right: rescue founder Dr. Philip Haigis, Frank Slipp, Clayton Urquhart, Percy Gower, Ralph Bennett, Leon Lary, and Ross Sherwood. The interior layout of the rescue unit was custom-built by Vernon Paulsen. (Courtesy Scarborough Rescue.)

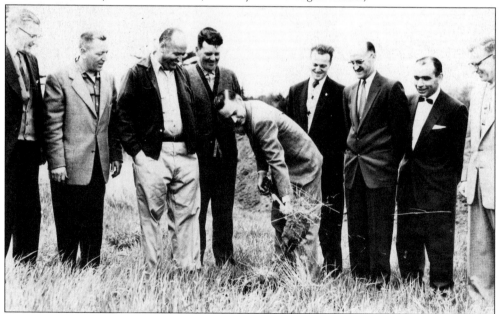

Construction on the athletic field beside the present-day high school began in the late 1950s. Shown at the ground-breaking ceremony are, from left to right:: Clifford Leary, Mike D'amico Sr., Linwood Higgins, Elwood Mitchell, Paul Scammon (with shovel), Dr. Philip Haigis, Jerry Hallett, George Stanford, and Thomas Vose. (Courtesy Robert Domingue.)

Seven

Dunstan

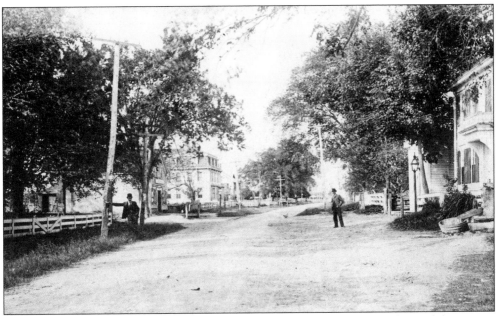

Elbridge Waterhouse (left) and William Graffam (right) photographed in front of their stores on Route 1. The residence of Mark Milliken, now the Hay and Peabody Funeral Home, is also visible. This photograph predates the trolley line which began in 1902. A chicken can be seen crossing the road near Mr. Graffam. More than most, this photograph represents the changes that have taken place in Scarborough during the past one hundred years.

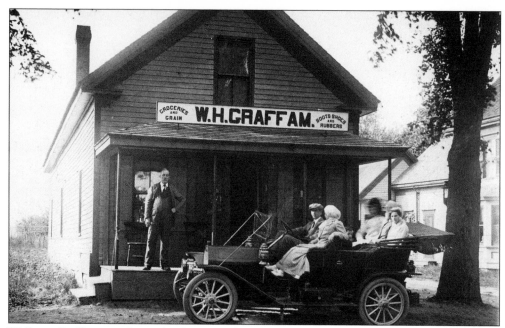

William Graffam stands on the front porch of his store. From my father's childhood in the 1920s, he recalls the cast-iron sink at the back of the store. A common dipper hung nearby for patrons to have a drink of cool water. Today, the building is the home of Village TV. (Courtesy Thomas Blake.)

The Southgate Mansion was built in 1804 by Dr. Robert Southgate. He had come to Scarborough from Massachusetts on his horse, with all his possessions in his saddlebags. He married Mary King of Dunstan Landing and they had twelve children. As time passed, the doctor became interested in law, gave up his medical practice, and became a judge. Sadly, he was predeceased by his wife and eleven of his children.

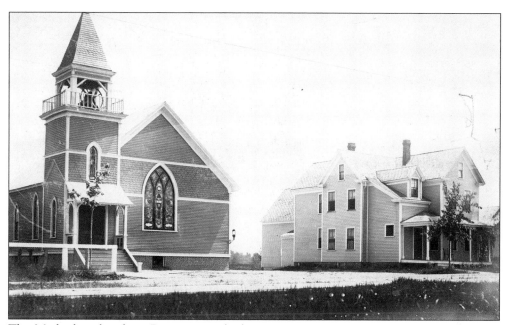

The Methodist church in Dunstan was built in 1839. In 1907, extensive renovations were made, changing the appearance of the church inside and out. It was at this time that the belfry and stained-glass windows were added. The parsonage was built in 1898.

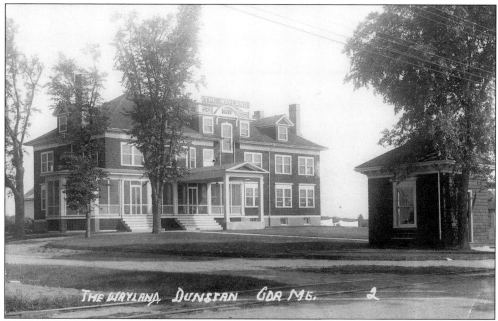

The Wayland, at the corner of Broadturn Road and Route 1, was a shore dinner house built in 1912. The original Wayland at the same site was destroyed by fire. For many years, this building served as the St. Louis Home orphanage. The building in the foreground was a waiting room for the trolley line.

This c. 1950 view of Dunstan Village was taken in the direction of Portland. Shore dinner houses and elm trees lined both sides of Route 1. In the distance, the Texaco star can be seen at the intersection of Pine Point Road.

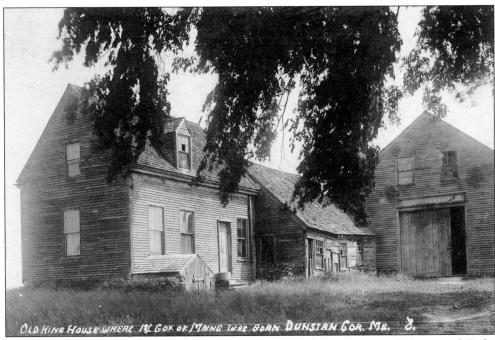

This house was the boyhood home of William King, the first governor of Maine, and Rufus King, who signed the U.S. Constitution. The house was torn down c. 1910 and another house built on the site.

Noah Pillsbury was Scarborough's first mail carrier. Shown here in front of his residence on Dunstan's Landing Road, he started carrying the mail in 1903 and held the job until 1919, when he died at the age of eighty-one. It should also be noted that he was the last toll collector on the Scarborough Turnpike across the marsh between Oak Hill and Dunstan. The tollhouse was near the Southgate Mansion. (Courtesy Scarborough Historical Society.)

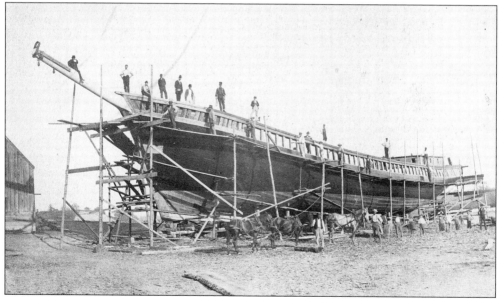

The *Delia Chapin* was constructed at Dunstan Landing in 1847. The area around the landing was called the Ship Yard. It was not uncommon for there to be one or more vessels under construction there at a time. Timber which was cut on the interior of southwestern Maine, was exported from the landing. Flood gates, built on the Dunstan River in 1877, severely restricted the flow of water. The change was so dramatic that today it seems hard to believe that a thriving port ever existed there. (Courtesy Scarborough Historical Society.)

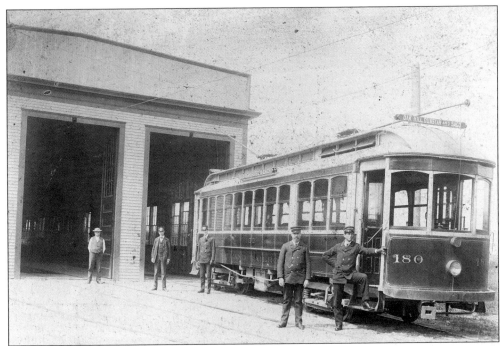

Trolley service began in Scarborough in July 1902. This car barn was located in Dunstan, next to the present-day Scarborough Historical Society building. The one-line track was on the westerly side of Route 1. To accommodate two-way traffic, turnouts were placed at intervals along the line. Trolleys ran on a thirty minute schedule, and it took about an hour to get from Monument Square in Portland to Saco. Service was discontinued in 1932, when Route 1 was widened to accommodate the increase in automobile traffic. (Courtesy Scarborough Historical Society.)

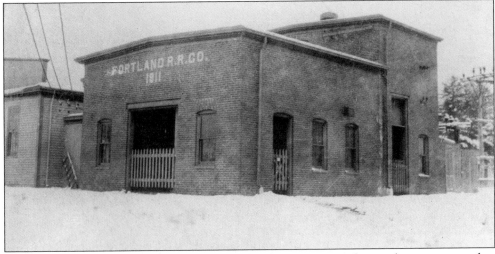

This building was built by the Portland Railroad Company to house the generators that provided power for trolley cars. A man was on duty here twenty-four hours a day. After the trolleys were discontinued, the building was used by Engine 6 of the fire department. It has been home to the Scarborough Historical Society since the early 1960s. (Courtesy Scarborough Historical Society.)

With the extension of trolley service through Scarborough, new businesses were established. Some businessmen took advantage of the natural resources available to them, using clams and lobsters as the foundation of the "shore dinner." The Moulton House was one of the first, located near the intersection of Route 1 and Broadturn Road.

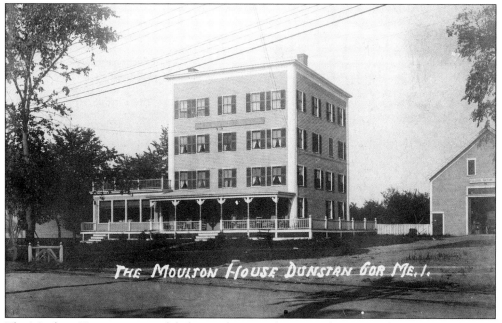

The Moulton House was remodeled several times. The original two-story house was built up to include four stories. In later years, it operated as Valle's Steak House. The business was eventually destroyed by fire, and a gas station now occupies the site.

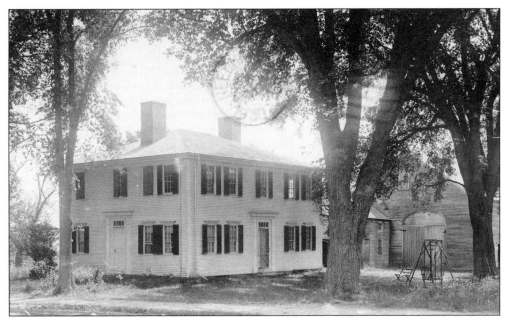

Known as the Dr. Bacon House, this building was actually built by Dr. Rice in 1792. It is most famous for the stop General Lafayette made here on June 25, 1825. Dr. Alvin Bacon was living in the house at that time. It has been moved back from Route 1, and has been the home of several families, including two other doctors. It was also a shore dinner house called Be Witch Inn for a number of years.

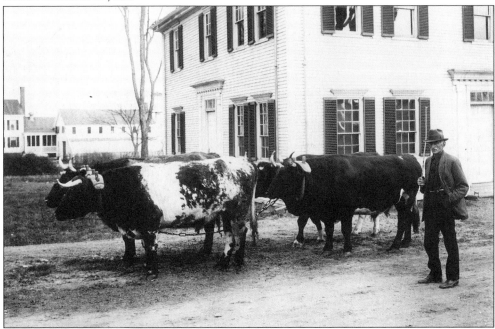

Alvin Moulton resided at the Dr. Bacon House for a number of years. Alvin was a cattle dealer who is remembered for his generous nature. He extended credit to many who purchased horses and cows from him. Along with his wife Annie he operated the Wayland, a landmark shore dinner establishment.

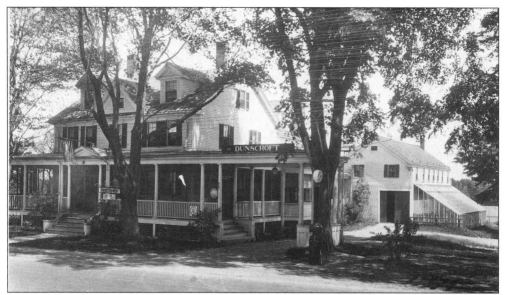

The Dunscroft was a popular shore dinner establishment located on Route 1 near Pine Point Road. The building, no longer open to the public, has been moved back from the highway.

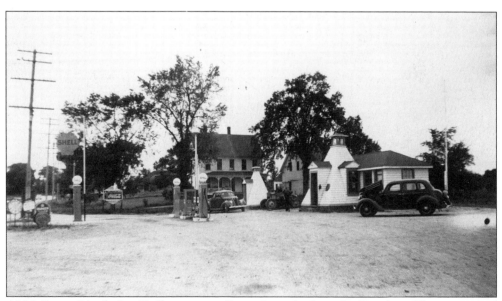

Al McConnell built this Shell station on Route 1 not far from the Saco line. The station and outbuildings were built in the style of a lighthouse. In the background is the home of Addison and Olive Laughton (the author's grandparents). The station was eventually torn down. (Courtesy Jim McConnell.)

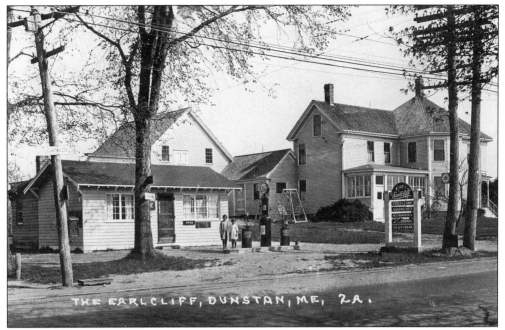

THE EARLCLIFF, DUNSTAN, ME, 2A.

The Earlcliff was a small eatery and gas station on Route 1. It was named for proprietors Earl Bennett and Cliff Leary. The business was short-lived and the small building was removed. A dining room was built on the main house and Earl Bennett continued doing business there as the Benway. The business was eventually sold and other restaurants operated there under a variety of names. Today it is home to Oliver Vending.

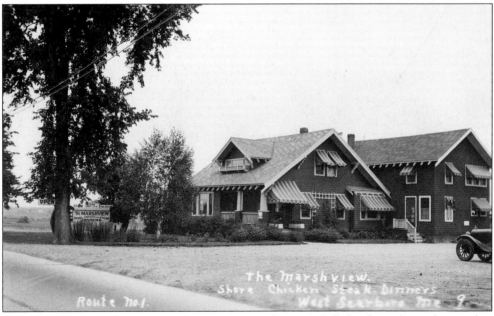

The Marshview. Shore Chicken Steak Dinners West Scarboro Me 9. Route no.1.

Percy Scammon was the first proprietor of the Marshview. Of all the shore dinner houses that were established in Scarborough years ago, it is the only one that has survived to the present time.

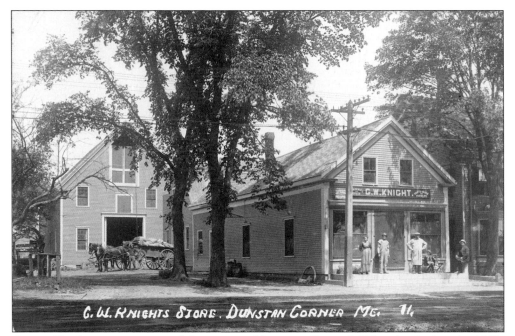

George Knight was proprietor of this store and livery on Route 1. When he died in the 1920s his wife continued the business. During World War II, Joe Knight, proprietor of the Atlantic House, ran the store.

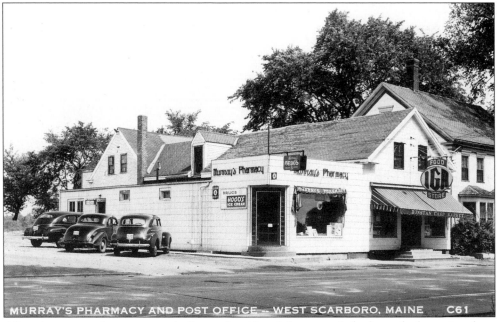

After the war, a pharmacy was built on the side of the store. It had a soda fountain where patrons could have coffee and ice cream. It was a completely separate operation from the store, with Elwood "Spud" Murray as proprietor. These buildings were consumed by fire in the early 1960s.

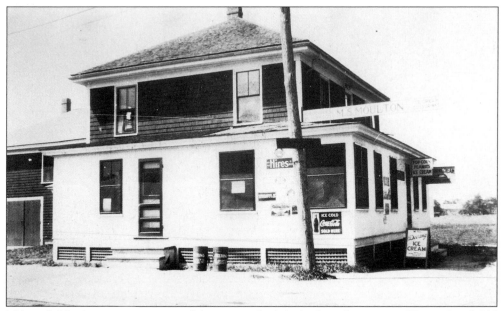

Milton S. Moulton was proprietor of this store, which he built at the corner of Route 1 and Old Blue Point Road. As Route 1 was widened, the road came so close to the building that there was no room for the front steps. Mr. Moulton moved the building to the next lot south, and it was remodeled into a house. He remodeled the garage that can be seen on the extreme left in this photograph into his new store, which is still in operation.

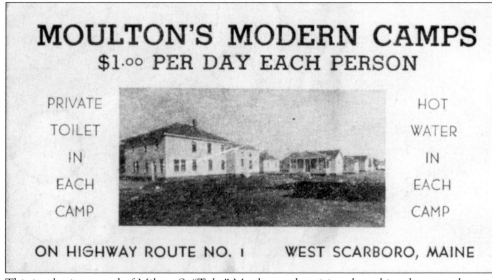

This is a business card of Milton S. "Tobe" Moulton, advertising the cabins that were located behind his store.

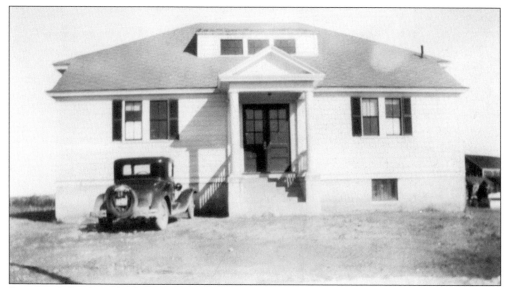

Dunstan School was built c. 1923 by Earl Leary. It served the community until a larger building was needed in the 1940s. After its days as a schoolhouse, the building was relocated to an adjacent piece of property and was the main building for Red Shutter Cabins. It was torn down in the 1980s.

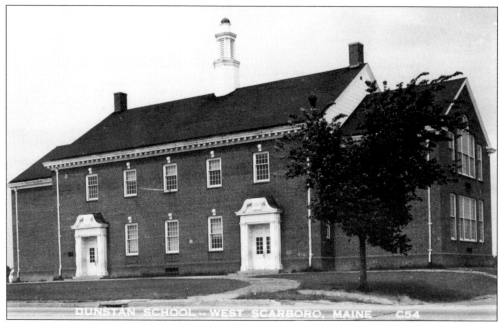

The last Dunstan School was dedicated in 1944. It was built as a replacement for its smaller predecessor. Building this school in the early 1940s was no small task, considering the shortages that were caused by World War II. The town closed the school in the early 1980s.

The honor guard at a late 1940s Memorial Day parade was photographed at Dunstan Cemetery. From left to right are: Vladimir Krijanovsky, Warren Delaware, Frank Winchester, James Scamman, Paul Scamman, and Everett Withee. (Courtesy Scarborough Historical Society.)

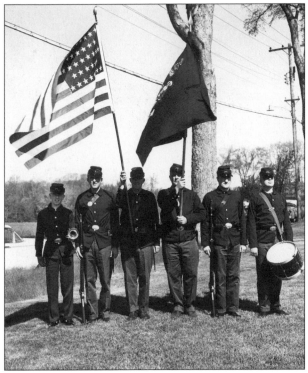

In 1960, the centennial year of the Civil War, Scarborough paid tribute to the 170 Scarborough men who served in the Union Army. Anna Delaware and Charlotte Dolloff made uniforms for the Memorial Day parade; the belts, buckles, cartridge boxes, and patches were either authentic or exact replicas. From left to right are: C. Richard Dolloff, Warren Delaware, Howard Merrill, Ralph Erickson, Richard Lippencott, and Neal Paulsen. (Courtesy Scarborough Historical Society.)

The Ground Observer Corp was an effort to monitor the movement of airplanes during and after World War II. Sponsored by the U.S. Air Force, volunteer citizens would watch for air traffic. This observation post was built on top of Edgar Thurston's garage in Dunstan village. (Courtesy Scarborough Historical Society.)

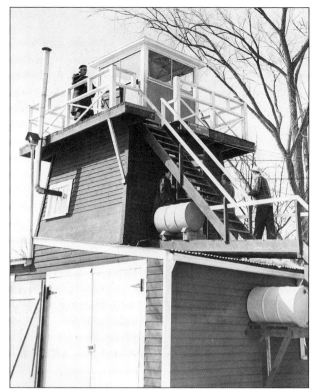

Florence Cunningham (left) and an unidentified volunteer watch for aircraft. Sightings were called in, giving any identification numbers, altitude, and the type of plane. During the war there was a fear of invasion along the coast. After the war, the program was continued due to tension created by the Cold War. (Courtesy Scarborough Historical Society.)

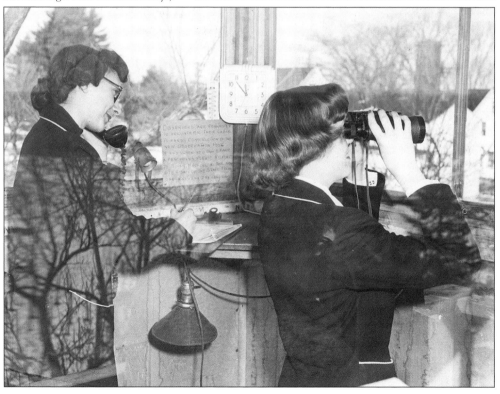

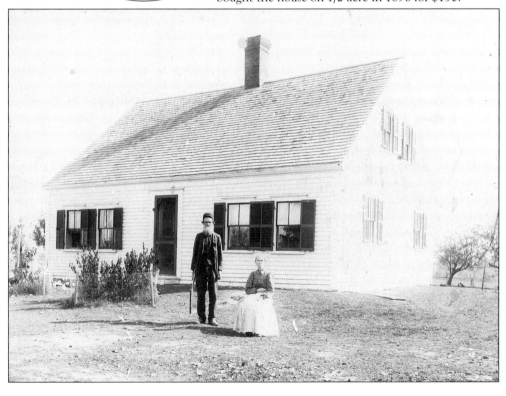

William Webster of Manchester, New Hampshire (the author's maternal great-grandfather), said that he had been in every state in the Union (there were twenty-seven at that time) and that he liked Maine the most. After his Civil War service, he settled on Broadturn Road, where he lived out his years. He is buried in Dunstan Cemetery.

John and Dorinda Laughton (the author's great-grandparents)are shown in front of their home on Route 1. The c. 1776 house is known as the Parson Chadwick House. The Laughton family bought the house on 1/2 acre in 1896 for $150.

Eight

Blue Point and Pine Point

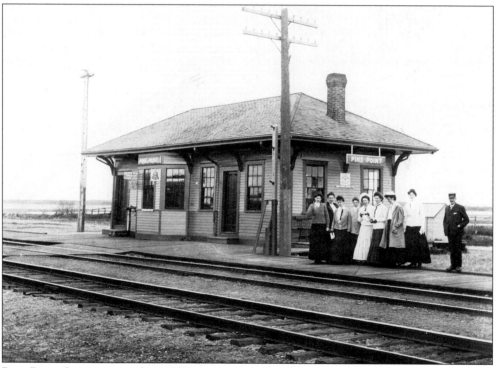

Pine Point Station opened in 1873, one stop south of Scarboro Beach Station. Fred Walker became the agent there in 1896. He had previously been the agent at Oak Hill. Sometime around the turn of the century, the station was moved from the west side of the tracks to the east side because passengers from Pine Point complained about having to cross the tracks to board the train. (Courtesy Harold Snow.)

Above: Children gather at the station in 1902 to see the Theodore Roosevelt train go through. The President was campaigning for the White House. He came to Maine on one other occasion, in 1912, to go hunting.

Below, left: Sportsmen were drawn to Pine Point to hunt the huge flocks of sea ducks that flew in and out of the Scarborough River. (Courtesy Robert Domingue.)

Below, right: Travelling minstrels pose for a photograph. (Courtesy Margaret Small.)

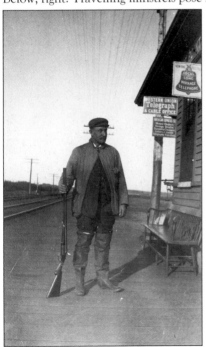

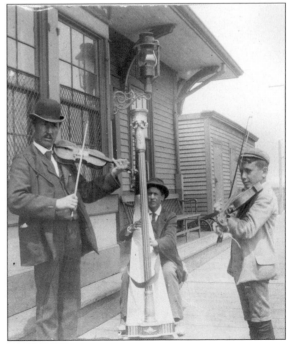

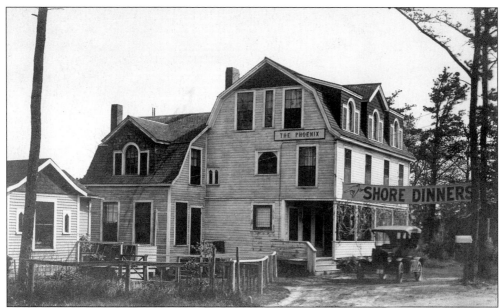

The Phoenix Hotel, on East Grand Avenue Extension, was operated by James Hayes from 1920 until his death. Robert Domingue, in his book *The Village of Cockell*, related that Mr. Hayes had the habit of sleeping in the barn with his horse. One evening in August 1939, the barn floor collapsed and Mr. Hayes and his horse fell through. The old gentleman, age eighty-nine, died as a result of the accident. The Phoenix was the only Scarborough Hotel of its day that advertised being open all year.

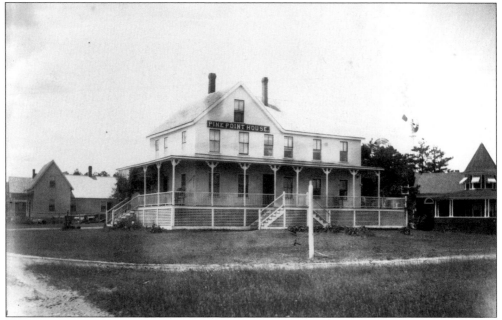

The Pine Point House was located on the waterfront at the end of Pine Point Road. Built in the 1870s, it was operated as a hotel first by M.F. Milliken, and then by A.A. Lawson. The building was finally razed and the site was used for an amusement park for a few years. It is now used as a parking lot.

Fred Snow (1890–1970) was born and raised in Scarborough. His father died when he was seven and at age ten, Fred left school and went to work digging clams to help support his family. In 1920, he opened a cannery at Pine Point and built his business until his clam chowder was a nationally known product. (Courtesy Harold Snow.)

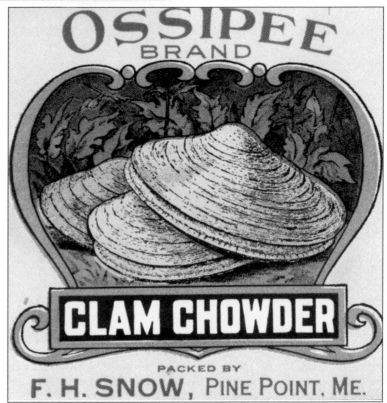

Snow's products were first marketed under the Ossipee brand name. In the mid-1920s the brand name was changed to Snow's. (Courtesy Harold Snow.)

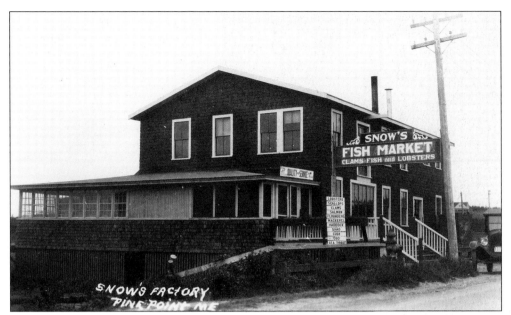

This is Fred Snow's cannery, as it appeared c. 1930. For the first few seasons he operated a shore dinner house during the summer months and a cannery for the remainder of the year. After three or four years, he gave up the shore dinners in order to run the cannery year-round. From 1927 to 1946 the porch of the factory was used as a seasonal fish market. For many years, his plant was the major employer in Pine Point. (Courtesy Harold Snow.)

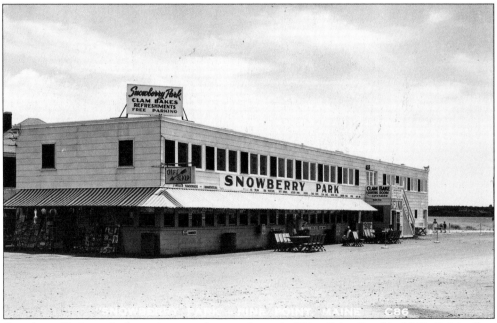

Snowberry Park was built on the waterfront at the end of Pine Point Road in 1947. Originally a partnership between Fred Snow and Perley Berry, the building had a takeout and gift shop on the first floor and a restaurant on the second floor. Ten years after opening, the building was sold and the new owners converted it into the Lighthouse Motor Inn.

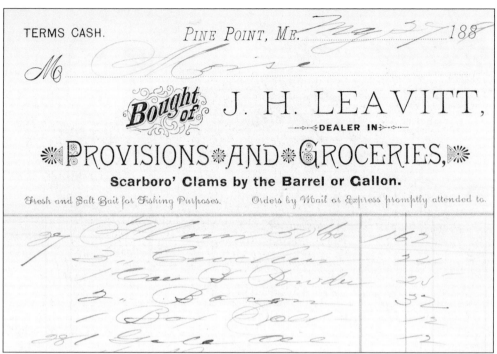

John Henry Leavitt was a merchant in Pine Point from the 1870s until just before his death in 1909. For many years, his store was attached to his residence on Pine Point Road near Snow Road. He served as postmaster from 1878 until 1902. His son continued the store until 1923. J.H. Leavitt's house would later be known as Ocean View House, where rooms were rented.

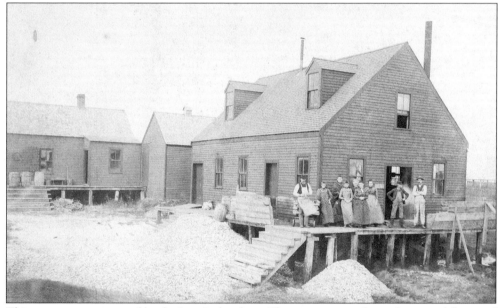

This cannery was operated by the Leavitt brothers. The cans were made on the second floor and the product was canned on the first (note the piles of clam shells in the foreground). Canneries were located in other parts of town, including Pleasant Hill and on the Payne Road. Products canned included: clams, chowders, fish, squash, and corn. (Courtesy Harold Snow.)

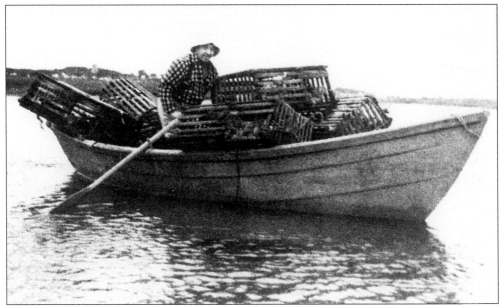

Above: A. Normindon Sampson rows a dory loaded with lobster traps. From the time it was settled, Pine Point has been home to families who made their living from the clamming, fishing, and related industries. (Courtesy William Bayley.)

Below, left: Ella Danforth tries her luck at digging hen clams. (Courtesy Margaret Small.)

Below, right: Hermidas Sampson cuts clams while his son Richard, stands by. This photograph has been affectionately called "Pine Point Gothic,"as it is reminiscent of the classic painting *American Gothic* by Grant Wood. (Courtesy William Bayley.)

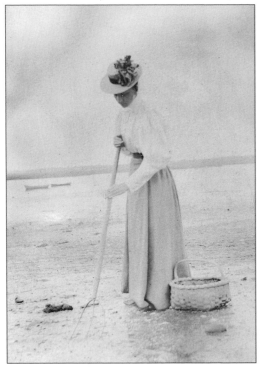
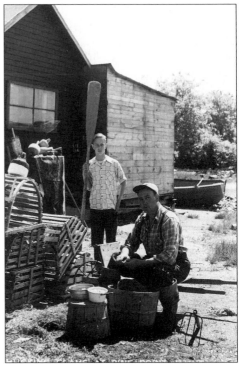

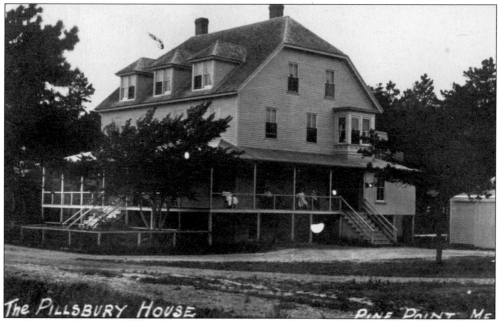

Built in 1888 and called the Sportsmen's Lodge, this was I. Winslow Pillsbury's replacement for his establishment of the same name that had burned the year before. In 1923, the name was changed to the Pillsbury House. It was a noted shore dinner establishment and remained in the Pillsbury family until the 1950s. It finally became property of the town and was torn down so the site could be used as a parking lot.

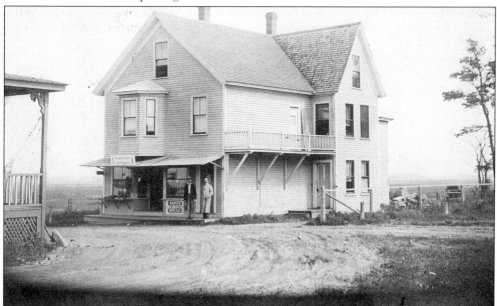

Woodman's Store was at the intersection of Pine Point Road and East Grand Avenue. Percy Woodman was proprietor of this store from 1900 until about 1935. From 1916 to 1924, the post office was located here. In later years, this store and the house and cabins that were adjacent to it were known as Morgan's. Today, the store has been converted into apartments. (Courtesy Scarborough Historical Society.)

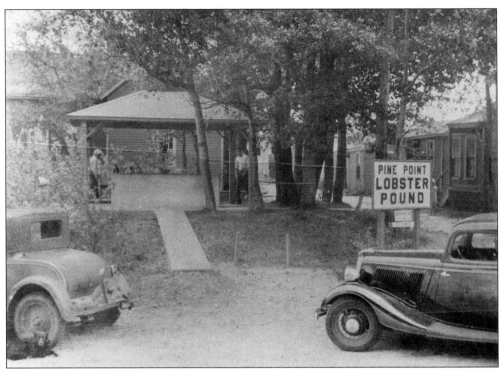

Stephen Bayley came to Pine Point c. 1915. He made a living digging clams and fishing for lobsters. In the early years, he sold his catch from his house or he would put lobsters in a suitcase and take the train to Portland, where there was a ready market. The family business has grown considerably and is carried on by Stephen's grandson Bill and his great-granddaughter Susan. (Courtesy William Bayley.)

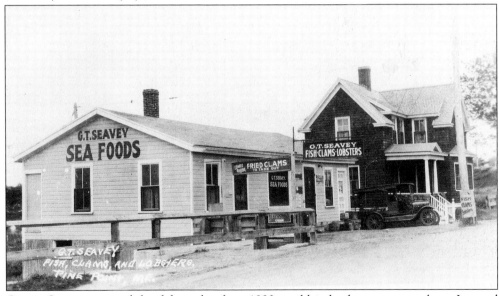

George Seavey operated this fish market from 1923 until his death twenty years later. Located on Pine Point Road, the buildings were razed when the railroad overpass was constructed in the mid-1950s. (Courtesy Robert Domingue.)

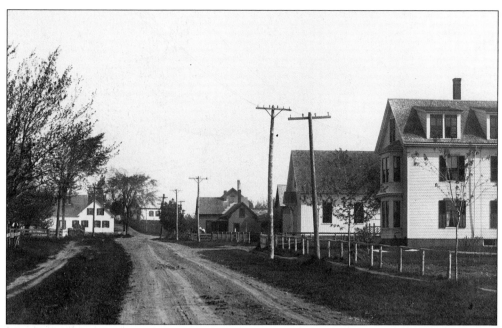

Blue Point School can be seen on the hilltop in this 1907 photograph of Pine Point Road. Looking in the direction of Blue Point, the first house on the right is the residence of Fred and Alice Walker, followed by Blue Point Church (before its reconstruction), and the Lothrop Homestead. The Baker Homestead is on the left side of the road. (Courtesy Harold Snow.)

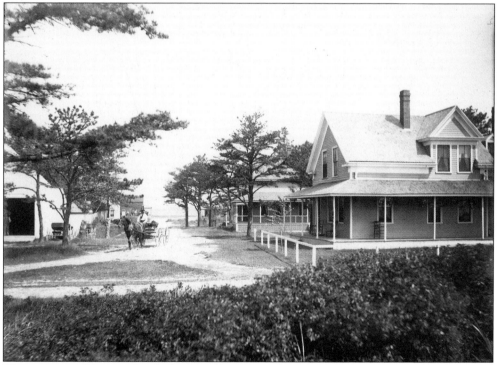

This is a view of Avenue 5 with the Merrill House to the right. The house was built in the 1870s and was in the family until the 1960s. King Street crosses in the foreground.

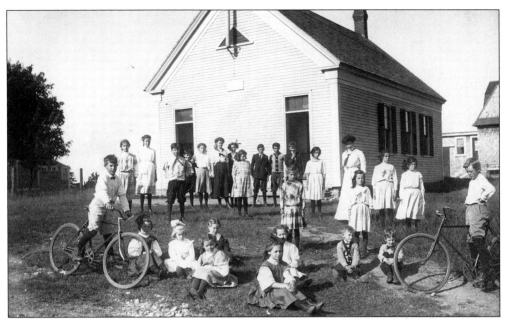

Blue Point School was built in 1867 as a traditional one-room schoolhouse. It is shown here in 1911 with a group of students. From left to right are: (front row) Louis Marcille (on the bicycle), Alma Seavey, Agnes Seavey, Elva Leavitt, Emily Barrows, Clara Seavey, Isabel Lothrop, Charles Seavey, John Snow, and Arthur Sullivan (on the bicycle); (middle row) Esther Davis and Theresa Merrill; (back row) Florence Walker, Mildred Barrows, Otho Baker, Laurence Seavey, Leora Snow, Carrie Turner, Pauline Proctor, Lucy Leavitt, Everett Davis, Ernest Merrill, Raymond Snow, Helen Merrill, Carrie Snow Leavitt (teacher), Ruth Merrill, and Jeanett Merrill.

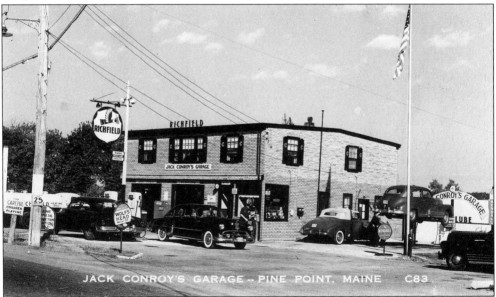

Jack Conroy built this garage and filling station on the corner of East Grand Avenue and Pine Point Road in the early 1940s. There was a garage previously on this site known as Baker's Garage. Mr. Conroy's sons continued the business after his retirement. Note the outside car lift.

Helen Perley (1904–1994) was proprietor of the White Animal Farm, established in 1934, on Seavey's Landing Road. A self-taught naturalist and expert on breeding mice and rats, she shipped worldwide. Research facilities sought her rodents for the purity of their breed. She supplied animals for television and the movies, from *Captain Kangaroo* to Alfred Hitchcock's classic, *The Birds*. Her practices were criticized by some, but she was loved by many. Helen's life was the subject of a 1970 biography called *Mrs. Perley's People*. (Courtesy *American Journal*.)

The First Christian Church of Blue Point was built *c*. 1885. In 1914, it was remodeled to include a heating system, exterior entry, and belfry. In 1947, the church was incorporated and took the name Congregational Christian Church. In 1957, a new and larger church was constructed a short distance away. The old church has been remodeled into a private home. (Courtesy Harold Snow.)

Nine
Beech Ridge and North Scarborough

In a scene reminiscent of a Norman Rockwell painting, neighborhood men enjoy a game of checkers inside Sherman's Store. From left to right are: (front row) Joseph Sherman, Archie Beckwith, Benjamin Roberts, and George Lowe; (middle row) George Maher, Harry Meserve, and Charles McLellan; (back row) T.E. Christopher is waited on by proprietor Orra Sherman. (Courtesy Peter D. Bachelder.)

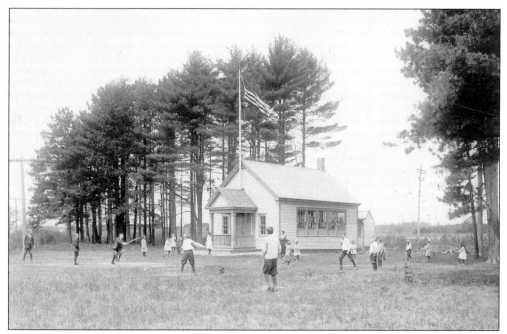

The one-room North Scarborough School stood on the south side of County Road, immediately east of the junction with Gorham Road. Classes were held in this building from *c.* 1875 until the expense of providing "modern toilets" caused the town to close the school in the spring of 1958. The following year, students were bussed to the newly completed Eight Corners School. (Courtesy Scarborough Historical Society.)

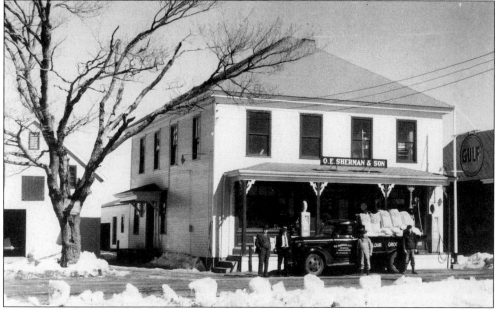

The O.E. Sherman & Son store was located on County Road near its intersection with Saco Street. It was started in 1865 by Joseph Sherman, and was operated by members of the family until it closed in 1982. From left to right are: Orra E. Sherman, Joseph B. Sherman, Phil Bragdon, and Clifford Meserve. (Courtesy Peter D. Bachelder.)

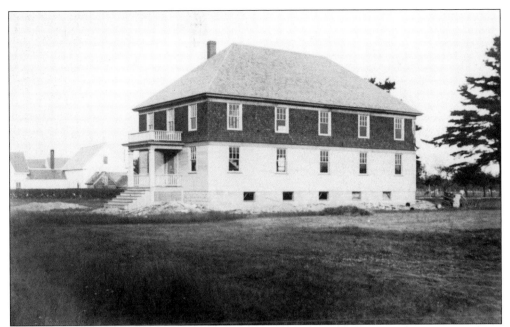

The North Scarborough Grange was organized on March 2, 1909, because of the long distance to what was then Oak Hill Grange, now Pleasantdale, on Black Point Road. Work on the hall was started in the spring of 1912, and its dedication took place on May 31, 1913. (Courtesy Barbara Griffin.)

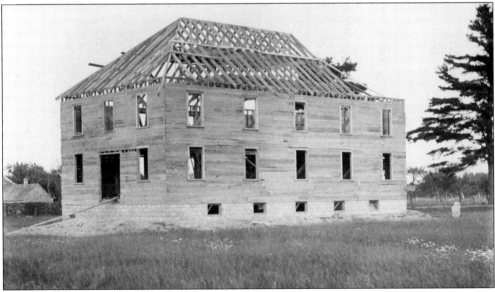

In December 1911, grange members voted to dedicate $1,251 to build a hall. The following is from the contract for the labor: "To the Committee of the North Scarborough Grange Hall. I have looked over your plans and specifications for the grange hall and have figured them carefully. I will put in cement foundation, will frame, raise, board, shingle, clapboard and finish the outside carpenter-work; will lay first floors, stud off rooms and halls, put up carriages for the stairs, joint in and hang windows and build the chimney all for $600... Signed, Fred Huff." (Courtesy Barbara Griffin.)

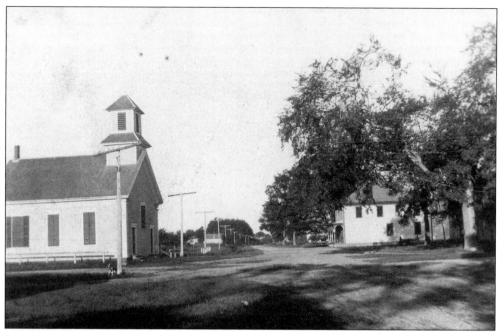

The Free Church, shown here in a *c*. 1907 view looking west along County Road, was built in 1871–72. Across the street is Sherman's Store. The church was razed in 1936, following years of disuse. (Courtesy Peter D. Bachelder.)

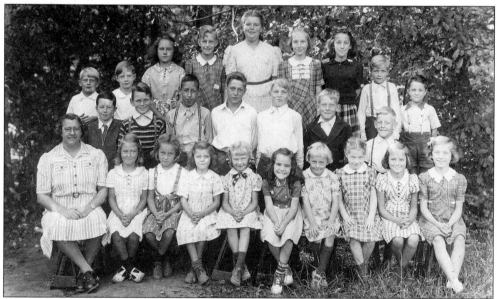

These were the students of Beech Ridge School, *c*. 1942. From left to right are: (front row) Helen Parlin (teacher), Jane Sherwood, Nancy Storey, Jane Googins, Pauline Alhquist, Barbara Emerson, Barbara Temm, Barbara Thompson, Marilyn Patnaude, and Elaine Lilley; (middle row) Gary Rice, Leroy Ahlquist, Olaf Ahlquist, Stanley Robinson, Edward Ahlquist, Charles Temm, and Albert Temm; (back row) Clifton Temm, Eben Lilley, Priscilla Storey, Eunice Lilley, Myrtal Guptill, Edna Lilley, Lois Patnaude, Clyde Googins Jr., and Bradley Patnaude. (Courtesy Albert Temm.)

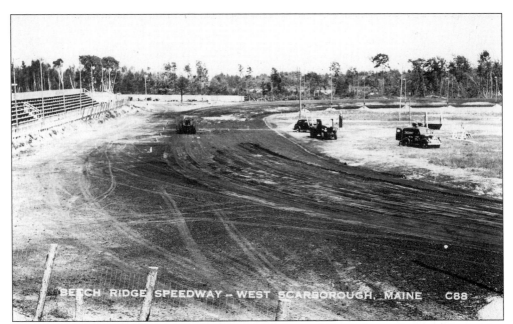

Jim McConnell brought auto racing to Scarborough in 1949. McConnell was in the lumber business, and he built the Beechridge Speedway on 100 acres that he had purchased for the timber. During the development of the property, the remains of a previous oval track were discovered. It was learned that this had been the location of the Ling Trotting Park, one of the first tracks in New England, which had been built on the site almost one hundred years earlier.

This was a complimentary pass to the Beechridge Speedway. By law, the person holding the pass still had to pay the 20¢ federal tax. Note that the address is listed as Vinegar Road. Later, the town would change the name to Holmes Road. (Courtesy Jim McConnell.)

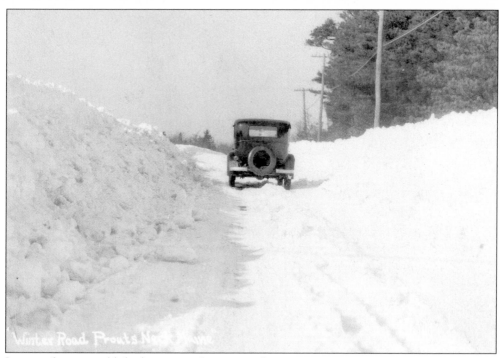

Images of winter published as postcards are rare; this snowy scene seems an appropriate way to say "The End."